S0-BNC-535

BREATHLESS HOMICIDAL SLIME MUTANTS

The Art of the Paperback

DREADFUL HOLLOW

Irina Karlova

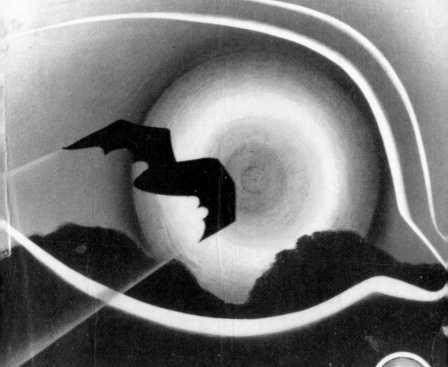

COMPLETE WITH CRIME MAP ON BACK COVER

A DELL MYSTERY

NO 125

BREATHLESS HOMICIDAL SLIME MUTANTS

The Art of the Paperback

Steven Brower
Foreword by Steven Heller

Universe

First published in the United States of America in 2010 by
Universe Publishing
A Division of Rizzoli International Publications, Inc.
300 Park Avenue South
New York, NY 10010
www.rizzoliusa.com

2010 2011 2012 2013 / 10 9 8 7 6 5 4 3 2 1

Printed in China

ISBN-13: 978-0-7893-1804-6

Library of Congress Catalog Control Number: 2009933346

Design by Steven Brower
Cover painting and pages 3, 5, 17 by Norman Saunders,
courtesy Zina Saunders

Page 4: Bantam Books, New York, 1948.

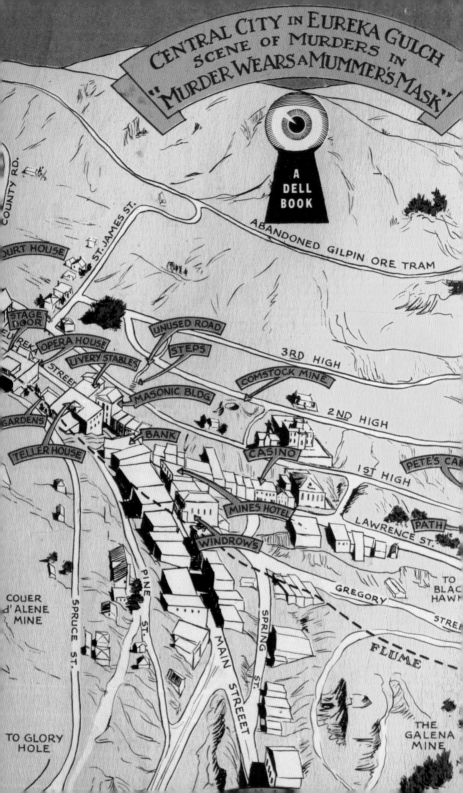

CENTRAL CITY in EUREKA GULCH
SCENE of MURDERS in
"MURDER WEARS a MUMMER'S MASK"

A DELL BOOK

COUNTY RD.

COURT HOUSE

ST. JAMES ST.

ABANDONED GILPIN ORE TRAM

STAGE DOOR

EUREKA

OPERA HOUSE

UNUSED ROAD

STEPS

LIVERY STABLES

STREET

3RD HIGH

COMSTOCK MINE

MASONIC BLDG.

2ND HIGH

GARDENS

BANK

CASINO

1ST HIGH

PETE'S CAB

TELLER HOUSE

MINES HOTEL

LAWRENCE ST.

PATH

WINDROWS

GREGORY

TO BLACK HAWK

STREE

COUER d'ALENE MINE

SPRUCE ST.

PINE ST.

SPRING ST.

FLUME

MAIN STREEET

TO GLORY HOLE

THE GALENA MINE

A Mass for Mass-Market Paperbacks
Steven Heller

In the beginning was the hardcover book, composed of multiple typeset pages containing knowledge and insight, tales small and tall, fiction and non. As the vessel of word and image, it offered pleasure and enlightenment; it bound messages and stories together, illuminated the mind, and made darkness light. And as time passed, the literate few did multiply and purchase more books, and the publishers who roamed the earth were blessed. Yet the hardcover was too costly for most people, so in its image—though somewhat more condensed, less smartly typeset and splendidly adorned—publishers begat another, somewhat smaller format that was fertile and appealed to the masses at a cheaper price. It was dubbed the mass-market paperback, and it was good, bringing literature high and low to those who might never have read a book before. Publishers quickly realized how successful their offspring was, and the industry rejoiced.

This homily should not be taken to imply that the success of the mass-market paperback was inevitable, yet the genre was a calculated risk that has certainly paid off over the past century. The general public, it was proven, yearned for volumes that could be read anywhere, without having to lug around cumbersome tomes. A book that could fit into a coat pocket—hence the trademarked and generic classification "pocket book"—was perfect for train, plane, or beach chair; sold on racks in drugstores, supermarkets, and terminals, they were an economic boon for their producers and an economical savings for their consumers. Inexpensive to print, they could be disposed of or passed on to others. This was key to the evolution of modern Western civilization, which had begun with the invention of movable type and the printing press during the fifteenth century. Mass-market paperbacks may not have been what Johannes Gutenberg or the Church had envisioned when the presses started pumping out ecclesiastical texts, but they were a force that altered what and how the masses consumed and digested—everything from pulps to classics, and eventually self-help books too.

Sometime during this evolutionary process, however, conventions were established that forever distinguished the look of mass-market paperbacks from hardcover books, and from yet another genre called trade paperbacks (which were ostensibly "soft-shell" hardcover books because they looked the same, only without the casing). At some key juncture, it was decided in the bowels of the publishing industry that mass-market

Mapback by Ruth Belew

books should be a particular size (based logically on the most cost-effective, standardized printing formats) and look a particular way (doubtless based on pseudo scientific assumptions by marketing experts about the aesthetic tastes of the masses). Some of those distinctions are as follows: Hardcover books looked more imposing; mass-market paperbacks looked more informal. Hardcover jackets were more artful; paperback covers were more commercial. Hardcover graphics were more nuanced; paperback covers titillated by leaving little to the imagination. Hardcover graphics merely suggested the content; paperback covers pounded the plot and/or characters home. Many hardcover books relied entirely on type to announce the book, while most paperbacks were realistically, romantically, or surrealistically illustrated. Nonetheless, despite the contrasting approaches (distinguished as literary versus commercial), at their very best and most effective, paperback covers exemplified a distinctive artistry. Moreover, the best of those who practiced the art of mass-market paperback design really understood how to capture the reader's attention and imagination.

It does not take a cognitive psychologist to know that a scantily clad woman will appeal to a certain segment of the male population, or that a well-endowed fellow embracing said woman engenders interest among female readers. It does, however, take talent to render the human form (expression and gesture) and garments (be they torn or tight) to stimulate a viewer's prurience. Not every illustrator is capable of being evocative. Yet not all mass-market paperbacks are so sensual or sexy: Mysteries must look mysterious, thrillers must look thrilling, horror must be horrible, and science fiction must be other worldly. All book jackets and covers are ostensibly advertisements, but the mass-market paperback must be the most convincing of them all. With only a limited time frame in which to attract the proverbial fish, the lure must be bright and shiny. Mass-market paperback artists and designers prided themselves on being incredibly alluring.

The most enticing and, at times, disturbing for its noir-like melodrama (albeit in color), Dell's popular "mapback" series serves as a model of the mass-market ethos in action. Influenced by the dime novels of the nineteenth century and the pulps of the early twentieth, Dell's mapbacks were seasoned with a hint of B movie. The Dell Publishing Company had been founded as a pulp house in 1921 by George Delacorte Jr., a 28-year-old entrepreneur. According to Tony Goodstone, who edited *The Pulps* (Chelsea House, 1970), the pulp novel—taking its name from the cheap newsprint on which it was printed—was "the cradle of sensationalism

in American art and literature" and featured some of the best (and worst) fiction ever written by the likes of Dashiell Hammett, Edgar Rice Burroughs, and Ray Bradbury. Delacorte's biggest sellers were adventure monthlies, such as *Danger Trail, Sky Riders, Western Romances,* and *War Birds,* all inexpensively printed and distributed through news dealers rather than bookstores. Soon he was a roaring success and by the late 1920s had branched out into magazines, including *Radio Stars* and *Modern Screen* as well as *Ballyhoo,* one of the most popular American humor magazines of the 1930s.

In 1942, Delacorte started Dell Books; by 1943, the first editions were released. To limit his liability and ensure efficient production, he forged a partnership with the Western Printing & Lithographing Company of Racine, Wisconsine, one of America's largest commercial printers, whose staff selected the titles, created the art, and printed the books, while Delacorte distributed them. It is estimated that between 1943 and 1945, some 11 million copies of Dell books were sold at a cover price of twenty-five cents each. By the end of the decade, sales had soared to 25 million (which was still short of the other major mass-market publishers, including Pocket Books' 50 million and Bantam's and New American Library's 30 million each). Dell was successfully competitive because the cover art that promoted its beguiling selection of titles—initially crime solvers by Ellery Queen, Rex Stout, Michael Shayne, and Brett Halliday, among others—was eye-catching for its raw sexuality. But to suggest that these books only pandered to prurient instincts would be an overly simplistic characterization of Dell and the paperback industry in general. Sex was periodically used, then disavowed, and then reprised by an industry that wanted to mirror public tastes rather than alienate them. Experimentation was not a concern.

In an attempt to transcend the saucy and hard-boiled pulp aesthetic perpetuated in Delacorte's magazine division, Dell Books, under the art direction of Racine-based William Strohmer and his assistant, George Frederiksen (who also painted a number of the covers), turned to expressionistic covers that used surrealism and dramatic symbolism to suggest the plot. Dell's leading staff artist, Gerald Gregg, adopted Dalí-esque tropes that he rendered primarily in airbrush. Gregg had a distinctive, simplified symbolic style that was enhanced by the airbrush's continuous tones and his preference for bright colors. Gregg referred to his covers as "stylized realism" and cited Norman Rockwell, Winslow Homer, and Andrew Wyeth as his influences. Despite these influences, Dell covers from

this period also borrowed graphic devices to elicit the fragmentation and isolation practiced by French posterists like A. M. Cassandre and Jean Carlu. Many of their motifs, such as the disembodied hand and eye, were adopted for Dell's covers.

Mass-market paperbacks in the 40s were also known for hand-lettered titles that were similar to the splash panels of comic books; however, Dell's lettering, drawn almost exclusively by Bernie Salbreiter, was more reminiscent of movie titles. American paperbacks had a very close relationship with the Hollywood thriller (whose plots were often torn from their pages). Most paperback covers, and particularly Dell's, had a crude aesthetic, largely owing to the fast pace at which they were produced—often between 5 and 10 titles a month, as many as 150 in a year. In Dell's case (but a reasonable assumption can be made that this was the industry way), such simplicity may have had something to do with the fact that most artists rarely if ever read the manuscripts, but instead worked from titles and a verbal synopsis of the contents—a process that was bound to result in a reliance on clichés.

Although the covers were based on brief summaries, the maps on the back covers required intense reading to determine what part of the plot would be depicted and then rendered (more or less exclusively) by Dell's in-house map maker, Ruth Belew. Her unmistakable linear style was as endemic to Dell Books as the company's eye-and-keyhole logo. Dell used maps as a standard feature from 1943 to 1951, capitalizing on the often photographic "scene of the crime" diagrams found in sensationalist newspapers.

The realistic period of Dell cover art ended around 1951, when it was decided that the art department should move from Racine to New York. The style that had distinguished Dell for nearly a decade was also becoming passé across the industry. Romantic realism had increasingly become the prevailing trend in illustration, especially in magazines. Dell's New York art director, Walter Brooks, not only preferred the sexy realism of Robert Stanley, one of Dell's leading artists, but one might say he modernized the overall look of the line by adopting sans serif lettering and replacing maps with blurbs. These changes did not hinder sales (in 1957, Dell made a small fortune by moving 8 million copies of Grace Metalious's *Peyton Place*, the highest-selling paperback at that time), but a special era in poster-like paperback art had definitely come to end.

Mass-market paperbacks evolved other conventions as well. While the basic size has remained the same over the decades, the tricks and tropes

have been pushed along with advances in technology. Multiple covers produced in different colors are now de rigueur. Fold outs and gatefolds, embossing and debossing, die-cuts and metallic inks are used to distinguish and attract. The design is still not as sophisticated or as nuanced as the hardcover, but many kinds of hardcover best sellers have borrowed liberally from the paperback.

In the beginning was the hardcover book, and there is no indication that it is going anywhere (despite the Kindle). But the mass-market paperback remains the most economical and portable, the most accessible and adaptable, of all the books on the market. Long may it stay.

Detail from *The Case of the Guilded Lily*,
Pocket Books, New York, 1961

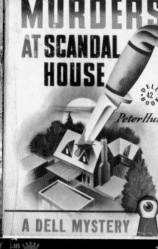

KENDELL FOSTER CROSSEN 25¢

YEAR of CONSENT

terrifying and
listic novel of
near future

T A REPRINT

MURDERS AT SCANDAL HOUSE

Peter Hun

42 BOOK

A DELL MYSTERY

IAN FLEMING

casino

A JAMES BOND THRILLER

royale

BY THE AUTHOR OF DOCTOR N

"A superlative thriller.
Replete with elegant
enigmatic women,
superb food and service,
explosions, torture,
and sudden death."
—Boston Sunday Post

51762

SIGNET

HANDI-BOOK MYSTERY 25¢

HE FOURTH STAR

RICHARD BURKE

385 CREST BOOK 35¢

ALFRED HITCHCOCK'S
most chilling movie from
the novel by ROBERT BLOCH

PSYCHO

An Alfred Hitchcock Production
Starring
Anthony Perkins, Vera Miles
John Gavin and Janet Leigh
A PARAMOUNT RELEASE

379

THE FRANK AUTOBIOGRAPHY
OF A FRENCH GIRL SOLDIER

GOLD MEDAL BOOK

Women's Barrack

TERESKA TORRES

EIGHTH PRINTING
1,640,000 COPIES SOLD

e Was A Way Of Life To Her POPULAR GIANT 35¢

THE GIRL FROM ROME

(TINA COLONNA)

MICHEL DURAFOUR

A novel of love

FREE! PERSONALLY
AUTOGRAPHED PICTURE
SEE PAGE 251

POCKET BOOK

Tiger Roan

GLENN BALCH

COMPLETE AND
UNABRIDGED

51587 SIGNET 35¢

THE ANALYSIS OF A MURDER

I Want to Live!

TABOR RAWSON

The sensational courtroom
battle that rocked the nation.
The story of Barbara Graham
... a 'bad girl' who was
tried for murder and con-
victed ... by her past.

With scenes from
the Figaro, Inc. Production
starring SUSAN HAYWARD.
Released thru United Artists.

A SIGNET BOOK

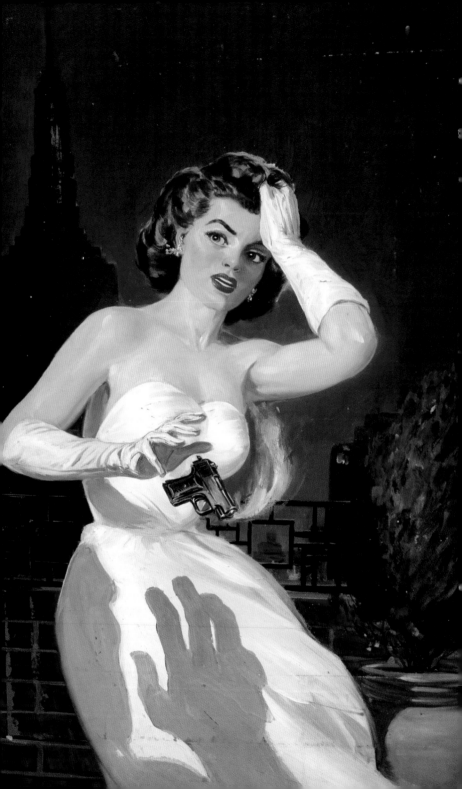

Breathless Homicidal Slime Mutants from the High Plains, and How I Learned to Love Them
Steven Brower

In 1968, John Leonard, then editor of the *New York Times Book Review*, listed the many merits of mass-market paperbacks: "They can be stuffed in purses, left in buses, dropped in toilets, used as coasters, eaten and thrown away. Their covers can be ripped off! Their spines can be broken! To buy a paperback today is to buy the means of revenging oneself on Western culture."

This affectionately flippant assessment may need to be revised now that the boom in digital media presents a threat to the printed word. The mass-market paperback deserves a serious look: More than an act of revenge on Western culture, buying a paperback these days may be a means of preserving one of its livelier species. And because no other publishing form has been so closely associated with its packaging, the history of the mass-market book—which is to say, the history of American literacy, tastes, and mores in the twentieth century—is inseparable from the history of paperback art and design.

Mass-market paperbacks are Western culture. In many ways, they are the highest form of what our culture aspires to: democratic, inclusive, utilitarian. While the hardcover and trade paperback book garner praise, reviews, and awards, the lowly mass-market paperback does the heavy lifting, disseminating information, knowledge—yes, even literature— among the many.

Julie Lasky, in an article for the *AIGA Journal* entitled "Design for the Masses," states that "the literary hardcover is the formal living room of the publishing industry. . . mass-market paperbacks, on the other hand, are rec rooms, where people spend a lot of their time doing the things they like best, the place that accommodates almost every interest." She continues: "What a nice departure from the sanctity of the printed word. . . . What a relief from monumentality and preciousness. Contrary to what snobs believe, mass-market paperbacks aren't always about drugstore roman- ces. . . . they aren't about glitzy covers, although this often prevails. In the end, I would argue, they are about comfortable informality and cheerfully infinite potential for abuse."

Generally, that "potential for abuse" prevails in the end. Mass-market paperbacks have been dubbed "pulp fiction" by many (a nomenclature

shared with their pulp magazine cousins); the term refers to the cheap paper used to make them, as well as their final destination—to be pulped, or boiled down and recycled. Inherent in this act of ephemeral destruction is yet another aspect of democracy at work.

The term dime-store novel sums it up: These editions are cost-effective and meant to be discarded. There is little expense incurred in the typesetting; pages are shot from the hardcover version and reduced in size, resulting in type so small that it often strains one's vision, regardless of illegibility or common sense. The book's sides are dyed various hues of red, yellow, green, and blue to mask the differing reams of newsprint within. The spine breaks with repeated readings.

Therefore, the financial investment on the part of the publisher lies in the cover. Unlike their more sophisticated brethren, mass-market paperbacks have traditionally been displayed facing out, first in five-and-dime stores and drugstores and today in supermarkets. Recalling his own days designing paperback covers, John Gall, the art director of Vintage Books, notes: "In a way, the thinking behind a cover could be as conceptual as any other type of design, though in a more general way. But the format is more about making the cover appear larger than the other 4 x 6 books it's sitting next to in Wal-Mart, which means the exploratory aesthetic work goes into things like stretching type, applying drop shadows, crazy printing effects—horrifying things you were told not to do in art school. My way of working was: If you think it's the way it should be done—do the opposite."

Indeed, as Gall observes, those "horrifying things" are a result of the environment in which these books are sold. The mass-market paperback has more in common with boxes of Tide detergent and Kellogg's cereal than the latest novel by Paul Auster—unless, of course, it's the paperback edition of the latest novel by Paul Auster. Sans reviews or appearances by the author on Oprah, a paperback is the ultimate impulse buy, best served with chips and beer on the way to the beach.

And these books were designed for a society increasingly on the go. Portable, fitting easily into one's jacket pocket, they can and should be read on trains and planes, and thus were duly dubbed "airport novels" (or, in an earlier day, "railway novels").

It is no coincidence that the rise of the mass-market paperback coincided with the Great Depression, since affordability quickly became an issue. In fact, similar economic conditions brought about the first incarnations of the paperback in the early part of the nineteenth century. A

cross between a newspaper and a magazine, the "penny dreadful" or "dime novel" quickly became a popular medium for serialized tales, often selling in the hundreds of thousands of copies with their weekly editions.

Rising literacy, better living standards, new manufacturing technology, and improved transportation resulting in wider distribution—all led to the further development and increased production of the written word, while economic upheaval furthered the need for inexpensive editions to be sold to the new consumer masses.

My own involvement with the mass-market paperback began in 1986, when I was employed in the cover department at New American Library. When I was about to graduate college, my portfolio professor handed out a sheet of paper. On it were listed the various areas of graphic design that we students should consider going into, arranged from top to bottom by projected income. "Advertising" stood at the top, and I believe "food packaging" followed. At the very bottom of the list was "book publishing," and I thought: *That's for me!*

Now, there was a raison d'être behind this decision: I loved books and reading. In those days, I knew little of the distinctions between "high" (cloth and trade paper) and "low" (mass-market paperback) book culture, and simply saw this as my way in.

My career in publishing was born. I worked in the bullpen with four other designers. It was our job to churn out some 30 to 40 covers per month. It was here that I learned the importance of the various genres and the design expectations for each: florid script faces for romance novels, wood type and slab serifs for Westerns, and (inexplicably) the German typeface Neuland for books about Africa. The art director had already commissioned most of the illustrations, and we simply had to select—and alter—compelling type to go with the various genres: sci-fi, Western, romance, historical romance, mysteries, thrillers, and so on. Mass-market paperbacks had long since been divided up into these genres—distinct categories that defined their audience and subject matter, a series of unspoken rules handed down from generation to generation. Indeed, during my brief tenure at New American Library, I employed more display typefaces in a year and a half than I will for the rest of my life. I also abused type more than I ever dreamed possible. Type was always condensed (stretched) so that the height would be greater in this small format. Sometimes we would even cut the type and extend it by hand.

And so it went. Every month, we would be given 5 to 6 titles we were responsible for, and every month, new variations on an old theme

would be hung up on the bullpen walls. For a brief period, I was assigned the romance titles, which themselves were divided into sub-genres (historical, Regency, contemporary, etc.). I made the conscious decision to create the very best romance covers in the genre. Sure, I would use script and cursive type, but I would use only the very best script and cursive type—so distinctive, elegant, and beautiful that I or anyone else would recognize the difference immediately. So imagine my surprise when, after leaving the job, I returned for a visit some months later and went to view my achievements on the wall, only to discover that I could not pick out any of my designs from the rest.

Hanging on the office walls (and also heaped on shelves and sadly forgotten in bins scattered about), artwork from the past beckoned. Two pieces hung directly outside the bullpen and, for me, summed up the incongruity of the form. One was an elegant pen-and-ink drawing by Milton Glaser for his Signet Shakespeare series, and the other was a realistic but lurid painting of a couple by James Avati. Displayed a few feet apart, there seemed to be little relationship between these two pieces of art other than quality—but as I came to understand, in many ways they represented the scope and breadth of the paperback format. Glaser's was all understated elegance, fine-lined cross-hatching with a spare use of colored ink—the effect one of an engraving contemporaneous with Shakespeare's time although created in the 1960s. Avati's sensational couple grimaced and lunged toward the observer, demanding his attention—rendered in dusty earth tones, the painting was very much a product of its time, the 1940s. Separated not only by two decades, but representing the written word across the centuries, these two pieces nevertheless summed up for me the original intent of the paperback: The written word is for everyone. Guilty pleasures coexisted with great literature, and both were available to all. Affordable, portable, and disposable, these books disseminated more information and entertainment than any other form of publishing—at least until the advent of the World Wide Web.

In today's publishing world, *individuality* is as quaint a term as *dust jacket*. Just as the mom-and-pop booksellers have been replaced by mega-stores like Barnes & Noble and Borders, so has the independent book publisher increasingly been acquired by larger publishing conglomerates. Imprints have been swallowed whole by the dozens. With formerly independent publishers reduced to imprints within much larger corporate entities, uniqueness is all the more difficult to achieve. The creative whim of individuals has given way to marketing and sales departments with an eye

Signet Books, New York, 1956. Artist: James Avati

1272

SIGNET BOOKS

25¢

THE LONG-AWAITED NEW NOVEL

by **Erskine Caldwell**

the world's
most popular
fiction writer

Love
and
Money

A SIGNET BOOK
Complete and Unabridged

on the bottom line. Maintaining a certain distinction was once a matter of course for independent publishers, both through their editorial selections and their choice of graphics. But now international corporations such as Bertelsmann, Pearson, and Viacom hold the keys to the kingdom, and the mass-market paperback has long since been eclipsed by the information superhighway.

Still, it is always worthwhile to take a look back and see where we've been. It is also a helluva lot of fun.

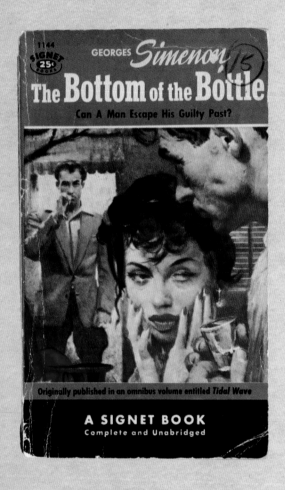

ABOVE: Signet Books, New York, 1954
OPPOSITE: Signet Books, New York, 1952. Artist: Rudolph Belarski

The Ernest Hemingway Prize Novel
SCIROCCO

A story of
primitive desires
in Sicily

Romualdo
Romano

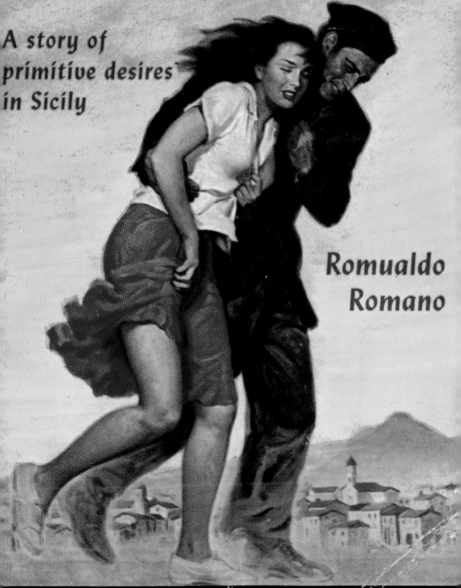

GENUINE POCKET BOOK NOVEL

The Birth of the Mass Market

The origin of the paperback book includes many of the elements that would later be featured in its pages: greed, betrayal, conspiracy, mystery, even witchcraft. During the Dark Ages in Europe, monks slaved away in scriptoriums, the predecessors of the modern-day publisher or book packager, where art directors/editors *(scrittori)* supervised both letterers (copisti) and artists (illuminators) to create illuminated manuscripts. These medieval publishing professionals often took from six months to two years to create a single edition of the New Testament. Embellished with silver, gold, and jewels, these books were works of art intended only for the elite, as the general populace in this feudal society spent their lives in illiteracy and poverty.

As early as the fourth century, the scope of these handmade books was broadened to include a book of poems by the Roman poet Virgil, as well as mathematical, scientific, and astrological texts. Still, these tomes were intended for the very few.

Johannes Gutenberg, the inventor of the printing press, was born around 1387 in Mainz, Germany. The son of wealthy patricians, he studied to be a goldsmith as a young man. Eventually he entered into a partnership to make mirrors, pouring melted glass over molten metal.

During this period, two technologies were completing their thousand-year journey from China to Europe: woodblock printing and papermaking. Many experimented with movable type, but Gutenberg, with his mirror-making background, had the equipment in place to bring these experiments to fruition. In China, movable woodblock type was utilized due to the tens of thousands of characters in the Chinese language; in Gutenberg's native Germany and across Europe, however, there were only a few dozen characters to contend with. Combining molten metal with the concept of movable type, and drawing the idea of the printing press from wine and cheese presses, Gutenberg would spend the next ten years of his life perfecting the process of printing, and another ten to produce his first book, an edition of the Bible, in 1450.

Having devoted his life to creating this new technology, Gutenberg let his livelihood as a mirror maker lapse and spent much of his family fortune investing in the future. Because of the expense and lack of income, Gutenberg was

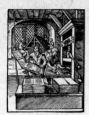

forced to borrow 1,600 guilders from Johann Fust, a wealthy merchant, using his printing equipment as collateral.

As Gutenberg's first print run, 220 copies of the Bible, was nearing completion, Fust called in the debt and sued Gutenberg for payment, taking possession of the equipment and locking him out of his own shop. Fust then entered into an agreement with Peter Schoeffer, who had been Gutenberg's assistant (and perhaps the first type designer), to oversee the business, and together they took over the press.

Upon publication of this first edition, Fust traveled widely across Europe selling Bibles to the upper crust. Since no one had seen a printed book before, he marketed them as handcrafted "illuminated manuscripts." However, since such "manuscripts" were prized possessions in wealthy households, many of his clients decided (unfortunately for Fust) to compare their books. Upon discovering that the printed editions were exact replicas of each other, without any variation, these patrons could draw only one conclusion: Witchcraft was involved. The only logical explanation for these uncanny reproductions was that Fust had sold his soul to the devil.

Fust was soon arrested and threatened with death until he was forced to confess the true origin of these editions. It was only after he agreed to pay back all the clients that he was set free. Still, Fust and Schoeffer continued to publish together out of Gutenberg's shop until Fust's death of the plague in 1466. This tale is believed to be the basis for the legend of Faust.

During this period, Gutenberg drifted into bankruptcy but eventually was able to establish a new printing shop. He published an encyclopedic dictionary in 1460 that sold quite well, and was thus able to reestablish himself in the field he had single-handedly created. It is believed that he was also responsible for inventing the process of engraving on copper plates, another great Renaissance innovation.

The Archbishop of Mainz appointed Gutenberg as a nobleman of the royal court, entitling him to clothing and keep for the rest of his life. When Gutenberg died on February 3, 1468, Mainz had become the center of printing. After Adolph of Nassau sacked the town and his army carried off the presses, this new technology quickly spread to France and Italy.

By 1480, there were printing presses in 23 Northern European towns, 31 Italian towns, 7 French towns, 6 Spanish towns, and 1 English town. By

1500, over 140 towns owned this technology, resulting in 35,000 editions for a total of 9 million books. The mass market in publishing had been born.

Shortly afterward, Aldus Manutius (1450–1515) established the first Italian printing press—Aldine Press, in Venice—to publish Greek, Roman, and Hebrew texts. In 1501, he produced the first "pocket-sized" book, *Virgil's Opera* (or "Collected Works"), which was only 3 3/4 x 6 inches tall. It was also one of the first books to feature italic typesetting, designed by Griffo (Francesco de Bologna, 1450–1518).

Experimentation with size and format continued throughout the centuries, even as rising literacy rates and better living standards created a greater demand for the written word. The invention of the steam engine led to a steam-driven rotary press, with the end result that books could be produced cheaply in large numbers, while increasing railroad and canal networks provided a wide-ranging means of distribution. *The Mysteries of Udolpho: A Romance Interspersed With Some Pieces of Poetry* by Ann Radcliffe (1764–1823) was published in 1794 and became the world's first best seller. With this work, Radcliffe virtually invented the gothic romance (along with Horace Walpole and his seminal *The Castle of Otranto* in 1764), replete with erotic desire, brooding villains, dark castles, and ghosts. Rather than appealing to the literary elite, *The Mysteries of Udolpho* was one of the first novels to capture the attention of the general public, and it benefited from cheaply produced reprint editions. Radcliffe became the first of many women authors to follow who, although dismissed by male critics, nevertheless achieved great commercial success. A paperback-sized edition of the novel was published in London as early as 1819.

Various attempts at producing cheaper books were explored around this time based on chapbooks, pocket-sized pamphlets that dated back to the sixteenth century. In Germany, publisher Karl Christoph Traugott Tauchnitz (1761–1836) produced a paperback book in 1809. In 1837, his nephew Christian Bernhard released his own series of paperbacks, the Tauchnitz Editions. An early popular chapbook, *Ivanhoe* by Walter Scott, was released in 1820 in England and America.

The Boston Society for the Diffusion of Knowledge began publishing inexpensive paperback books in 1829 and even started its own imprint, the American Library of Useful Knowledge, in 1831. *The Posthumous Papers of the Pickwick Club*, the first novel by Charles Dickens, was published in England by Chapman & Hall in 1836 in the form of bound signatures,

with paper covers, and released in monthly chapters. Sales jumped from 1,000 for the initial printing to a circulation of 40,000 by the time the series ended. Even more cheaply produced bootleg copies soon surfaced to compete with the authorized versions.

Beginning in 1830, these paperback editions became known as "penny dreadfuls"—affordable works of fiction that were serialized over several weeks or months and sold for a penny in Britain at newsstands and in dry-goods stores. Printed on cheap paper stock, several signatures of the work could be bound together with a paper cover, or collected at a later date to be published as a hardcover book. Circulation reached as high as four hundred thousand copies per issue.

Originally aimed at working-class adults, by 1850 these books were marketed to teenage boys. Often containing lurid true-crime tales, Western adventures, and gothic thrillers, the penny dreadfuls came to be seen as a corrupting influence on England's impressionable youth (hence the "dreadful" part). Eventually, this format would evolve in two directions: the pulp magazine (and later the comic book), and the mass-market paperback. Their common root turned out to be a portent of things to come: A century later, American comic books would come under similar attack with the publication of Dr. Fredric Wertham's *Seduction of the Innocent* (1954).

The American writer James Fenimore Cooper (1789–1851) soon became a popular author in this new format, with stories of Native Americans battling settlers in his *Leatherstocking Tales* and high seas adventure in *The Pilot* (both 1823). These stories romanticized American history and the settling of the Far West. In 1826, Cooper published his masterpiece, *The Last of the Mohicans*.

Another example of early mass-market success was *Uncle Tom's Cabin* (1852) by Harriet Beecher Stowe (1811–1896). Simultaneously published in the United States and England, the book had ten different editions appearing in a two-week period. To date, *Uncle Tom's Cabin* has sold 28 million copies worldwide.

The term "penny dreadful" (and subsequent "half-penny dreadful") was soon joined by another—"dime novel"—with the advent of New York publisher Beadle & Adams and its "Beadle's Dime Novels" series. *Malaeska, the Indian Wife of the White Hunter* by Ann S. Stephens was published in 1860, retailed for 10¢, and sold over 65,000 copies within the first few months of publication. This initial success led Beadle & Adams to

publish a dime novel every two weeks, and later once a week. The dime novels were roughly 4 1/4 x 6 1/2 inches, 100 pages in length, and soon sported engraved cover illustrations. These small books were so popular that they were taken to the battlefield for the first time during the Civil War, where they were read by Union and Confederate soldiers alike.

Illustrated covered editions soon became known as "yellowbacks" in England due to the cover stock utilized. A popular illustrator and designer of the day was Alfred Crowquill (né Alfred H. Forrester, 1804–1872), who created covers for many of these books engraved in black and printed in two colors.

Not all of these books were geared toward males. *The Book of Household Management, Comprising Information for the Mistress* (1861) by Isabella Mary Beeton (1836–1865) contained fashion and child-care advice and numerous recipes, and ultimately sold well over 600,000 copies.

"Story papers," yet another early form of the paperback, were weekly eight-page tabloids featuring material and themes meant to appeal to the whole family. Many had circulations that rivaled newspapers or magazines, reaching 400,000 copies per issue. Unlike dime novels, which generally confined illustrations to the cover, these included wood engravings throughout.

In 1894, *Trilby*, a gothic horror novel by George du Maurier (1834–1896), introduced the name Svengali into the lexicon. Trilby's sensational mix of hypnotism and sexual tension made it an instant best seller. Among the illustrations scattered throughout the book was a caricature of James Abbott McNeill Whistler (1834–1903), the popular artist (and du Maurier's former fellow art student). Known for being litigious, Whistler threatened to sue, causing du Maurier to soften the image for the next edition. But the subsequent publicity—well covered in the day's press—only served to increase sales. The book proved so popular that hats, dances, soaps, toothpaste, and even a town in Florida were all named for its eponymous heroine.

These early forms of the mass-market paperback reached their zenith by the end of the 19th century. The invention of the typewriter made it possible for more work to be created at an even quicker pace. The Library of Congress's holdings include nearly 40,000 titles from 280 different dime-novel series.

During this era, novels were eclipsed in popularity by pulp magazines. In the latter part of the 19th century, magazines like *Harper's*, *The Century*, *McClure's*, and *Munsey's* proved quite popular. They were

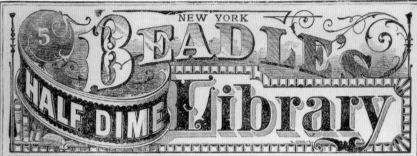

NEW YORK
BEADLE'S
HALF DIME Library

bar

COPYRIGHT, 1881, BY BEADLE & ADAMS. ENTERED AS SECOND CLASS MATTER AT THE NEW YORK, N. Y., POST OFFICE. July, 1901.

No. 1115. Published Every Month. M. J. IVERS & CO., Publishers,
(JAMES SULLIVAN, PROPRIETOR),
379 Pearl Street, New York. PRICE 5 CENTS. 50c. a Year. Vol. XLIV.

TIGER TOM, THE TEXAN TERROR.

BY OLL COOMES,

AUTHOR OF "LITTLE HURRICANE," "OLD SOLITARY," "LITTLE TEXAS," "EAGLE KIT," "LONG BEARD," ETC., ETC.

STILL GRASPING THE SERPENT, HE SWUNG IT ALOFT LIKE A WHIP AND STRUCK THE BEAR A FEARFUL BLOW.

PREVIOUS PAGE: Beadle's Half Dime Library, New York, 1901. THIS PAGE FROM TOP: James R. Osgood and Company, Boston, 1874. 4.25 x 6 inches. Hurst & Company, New York, 1889. 4.125 x 6 inches. OPPOSITE: World Almanac, 1891

printed on high-grade stock, approximately 7 x 10 inches in size, and featured many of the best writers and illustrators of the period. Due to the costs entailed in producing these slick publications, their price was between 50¢ and $1.00 per issue, rendering magazines a bourgeois endeavor. Seeking out a more cost-effective variant—one that would appeal to the working class—publishers experimented with cheaper paper (pulp or newsprint) and hired lesser-known writers and illustrators.

The pulps first appeared around the end of the 19th century and combined serialized writing with often racy cover art that satisfied an urge for exaggeration: Athletes were stronger, heroes nobler, and women more luscious—and usually in danger. Their pages were filled with intrigues featuring crooked cops, clever criminals, sinister spies, and dangerous femme fatales. The size, general content, and lurid illustration would eventually morph into the American comic book in the 1940s. A smaller "digest" version, 5 x 7 inches, came into being as well. Publishers like Dell, Ace, Popular Library, and Fawcett enjoyed great success with such tantalizing titles as *Captain Billy's Whiz Bang*, *Amazing Tales*, *Weird Tales*, *Secret Agent "X"*, *Thrilling Adventures*, *Crime Buster*, *Spicy Detective Stories*, and *Doctor Death*. The pulps also featured the work of newcomers like Dashiell Hammett, Raymond Chandler, H. P. Lovecraft, Edgar Rice Burroughs, Zane Grey, and countless others.

Still, the form of the paperback book was merely lying dormant, waiting to make a comeback—and with a vengeance. In the early twentieth century, many variations on the paperback sprang up across the continent. Little Blue Books and BoniBooks were two such experiments, the latter featuring covers by popular illustrators of the day like Rockwell Kent (1882-1971). Another was the Jacket Library, located in Washington, D.C., which offered affordable though lackluster versions of the classics. All three suffered financial losses with the advent of the Great Depression, ending their endeavors. In Germany, Albatross Books began publishing paperbacks in 1931, but it too was short-lived, succumbing to economic and political strife.

It wasn't until 1935, in England, that the current incarnation of the mass-market paperback took hold. Publisher Allen Lane launched the Penguin imprint with André Maurois's *Ariel* and several other reprint titles. Procuring paperback rights cheaply from the hardcover publishers, Lane was able to keep his costs down with fairly large print runs of around 20,000. Penguin's books were an immediate success, both in Britain and the United States. These early Penguins did not feature cover illustrations, simply displaying the title, author, and logo on a flat col-

or field, and were priced at sixpence in the U.K. and 25¢ in the U.S.

One distribution coup for Penguin was selling books through F. W. Woolworth, an American retailer since 1878, which had opened stores throughout England in 1909. This forerunner of the chain store agreed to sell books alongside dry goods and medicinal products, giving rise to the long-standing relationship between food, soap packaging, and paperbacks, as well as an enduring distribution avenue beyond the traditional booksellers. Commonly known as "five-and-dime stores," this new outlet for book sales lent itself to a new nomenclature: "dimestore novel." Other nontraditional venues for these books included railroad kiosks in the U.K. and newsstands in the U.S. Approximately 1 million copies of Penguin's first 10 titles were sold within 6 months of their introduction, with over 3 million sold in the first full year.

An American living in England, Ian Ballantine (1916–1995) was hired to establish an American office for Penguin—but before he could, an American company jumped the gun and into the market. In 1939, Robert Fair de Graaf partnered with Simon & Schuster to form Pocket Books, and the term *pocket book* entered the lexicon. Following Penguin's lead in England, Pocket Books sought out and won Macy's department store as a nontraditional book venue and, with an initial order of 10,000, was off and running. As a test run, it produced 2,000 copies of *The Good Earth* by Pearl S. Buck, to be distributed only in New York City; it sold over 800 copies on the day it was released. The first numbered Pocket Book soon followed: *Lost Horizon* by James Hilton, originally published in hardcover in 1933. The Pocket Book edition was priced at 25¢ and became an instant bestseller. This paved the way for a numbered edition of *The Good Earth* as well as works by Shakespeare, Thornton Wilder, Dorothy Parker, and Agatha Christie. Most significantly, Pocket Books—in contrast to Penguin and its discreet covers—hired illustrators to adorn the books with colorful, eye-catching graphics, many of them similar to their pulp-magazine brethren. From this time forward, the paperback format and brash illustrations would be linked under the catchall phrase *pulp fiction*. Despite the literary and artistic merit of the work contained within (or lack thereof), mass-market paperbacks would forever be branded as "lurid," "trashy," and "kitsch." Pocket Books also had notable success in various genres of nonfiction, such as self-help books. In 1940, *How to Win Friends and Influence People* by Dale Carnegie became the first paperback book to break the 1-million-sales mark. In 1945, Pocket Books published what still stands as one of the best-selling paperbacks of all time, *The Common Sense*

SHOW GIRL

J. P. McEVOY

GOLD MEDAL BOOKS · INC.

Gold Medal Books, New York

Book of Baby and Child Care by Dr. Benjamin Spock, which by 1998 had sold more than 50 million copies and been translated into 39 languages.

Other genre mainstays adapted from the earlier dime novels and pulp magazines took hold as well: science fiction, romance, mystery, horror, Western, and true crime. The paperback format even gave birth to some new ones: movie (and later TV) tie-ins, movie "novelizations" (based on the screenplay), celebrity exposés, and instant books (works written, designed, and printed on demand to capitalize on breaking, often sordid news).

Lesbian fiction made one of its first appearances with *Spring Fire* by Vin Packer (née Marijane Meaker, b. 1927), published by Gold Medal in 1952. The first graphic novel is considered by many to be *Blackmark* by Gil Kane (1926–2000), a science-fiction/sword-and-sorcery comic book published for the first time in paperback form by Bantam Books in 1971. Even the term *film noir*, labeled by the French film critic Nino Frank (1904-1988), had its roots in the paperback crime novel.

Other publishers soon followed up on Pocket Books' success. In 1945, Ian Ballantine left American Penguin and, together with Random House founder Bennett Cerf (1898–1971), created Bantam Books; in 1952, he founded his own company, Ballantine Books. Ballantine experimented with publishing paperback originals on a wide range of subjects and was responsible for the successful introduction of reprint collections from humor magazines such as *Mad* and *Humbug*, as well as an anthology of *Lil Abner* comic strips by Al Capp. Ballantine also found a thriving market for its myriad science fiction titles, including books by Arthur C. Clarke and Frederik Pohl, and was the first to publish J.R.R. Tolkien's novels in paperback.

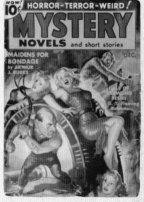

After Ian Ballantine's departure, American Penguin split from its British parent and became New American Library, with the egalitarian slogan "Good Reading for the Millions"; the Penguin line became Signet and the Pelican line, Mentor. Pulp magazine and comic book publishers Dell and Fawcett entered the field in 1943. Other magazine publishers, both pulp and general interest, soon joined the fray, including Avon, Graphic, Popular Library, Lion,

and Pyramid. In 1949, Fawcett introduced the paperback original under its Gold Medal imprint, culling authors from its pulp magazines and releasing hundreds of newly published titles (the first 78 alone sold 29 million copies).

With the paperback gold rush going strong, other publishers followed suit. Hardcover publishers such as Knopf, which introduced Vintage in 1954, began publishing paperbacks as well—these were slightly larger than the existing paperback, but paperbacks nonetheless. This led to the creation of the "trade paperback," a larger version still, which was only slightly smaller (at 5 1/2 x 8 1/2 inches) than the 6 x 9 inch hardcover it was often reprinting, thus creating a more dignified relative to the lowly mass-market paperback. Still, companies like Vintage, Anchor, and their ilk tried to have it both ways, producing numerous titles that would slip easily into a jacket pocket. Conversely, so did the pulp-magazine publisher Avon, which chose Shakespeare's likeness for its corporate colophon, a nod to his birthplace of Stratford-upon-Avon.

World War II proved to be another boon for the mass-market paperback. As with the Civil War before it, soldiers on the move had plenty of downtime and many hours to fill, and a pocket-size tome fit that need perfectly. In addition to books released to the general public, publishers produced special editions for the armed forces. Originally, they tried to fill this demand on their own, but the attempt proved unrealistic, so they began working directly with the government to produce these special editions. Penguin Books, no longer able to import its books readily from England, began to publish in the U.S.; in conjunction with the military, it introduced its own Infantry Journal Books. Pocket Books alone produced upwards of 25 million books for the Army, the Navy, and the Red Cross.

The Council on Books in Wartime was formed in 1943 to oversee these publications. Chief among them were the oddly horizontal Armed Services Editions, paid for by the U.S. government and shipped for free to enlisted men. With over 10 million people serving in the armed forces at the height of the war, the appetite for recreational reading was immense: Some 1,300 titles were produced with print runs of over 100,000, resulting in an excess of

TOP: Liveright Publishing Corporation, New York, 1926. BOTTOM: Penguin Books, Great Britain, 1945. OPPOSITE: Rowohlt, Hamburg, 1950

ERNEST HEMINGWAY

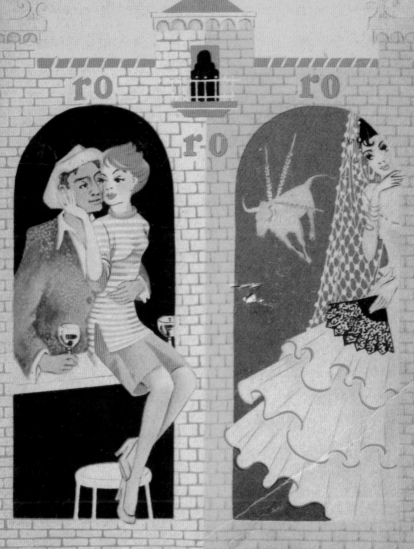

FIESTA

THE ECHOING GROVE

Lynton Lamb

ROSAMOND LEHMANN

COMPLETE 3/6 UNABRIDGED

125 million copies in circulation. These editions were printed "two up" on presses built for pulp magazines, then sliced down the center and stapled—hence the unorthodox size. Oddly, the covers featured a photograph of the hardcover edition; compilations of short stories and poetry occasionally displayed photos of a hardcover book that didn't exist. The cost to the government for producing these editions was approximately 5¢, each with an additional 1¢ royalty split between the publisher and author. Still, despite the low overhead and profit margin, these special editions helped keep the industry churning along during the war years.

Stateside, the trade continued to grow. Despite paper shortages and rationing, the number of books printed and sold increased, with fewer returns. Inside the books, publishing companies ran ads encouraging families to ship their copies to servicemen overseas. Pocket Books even established a service for Americans being held in P.O.W. camps.

When FDR died in office on April 12, 1945, Pocket Books issued the first instant book a mere six days later—*Franklin Delano Roosevelt: A Memorial*, with an initial printing of 300,000. This paved the way for other innovations. Ace became known for offering two and even three novels in one volume, for the increased price of 35 and 50 cents, respectively. These Ace Doubles featured two novels bound back-to-back under separate covers; the reader would simply flip the book over once finished and begin again. At Lion Books, editor-in-chief Arnold Hano would outline a plot and then commission writers such as David Karp and John Thompson to flesh them out at novel length. Dell experimented with 10¢ editions, 64-page books that were saddle-stitched but proved unpopular. Ironically, Pocket Books and Bantam both began to add dust jackets to some of their paperbacks, either to help lagging sales on a particular title with new art, or to tie in with a soon-to-be-released film version. Conversely, Perma (owned by Doubleday) published "hardcover paperbacks"—paperback-sized cloth editions selling for 35¢. Most of these were nonfiction and were used by schools as inexpensive supplementary textbooks. Publishers also experimented with paperback vending machines at train stations and airports, but these failed to take hold. More successful were paperback racks—first made with wood and then iron rods—to display their wares.

After the war, the paperback continued to flourish and keep up with changing times. New publishers such as Harlequin, Checker, and Berkley jumped into the market in the late 40s and early 50s. Bantam Books enjoyed several million-sellers between 1948 and 1950, including *The Wayward Bus* by John Steinbeck and *A Stranger in Paris* by W. Somerset

Penguin Books, Great Britain, 1958. Artist: Lynton Lamb

Maugham. Starting in 1946, Signet had similar bestseller success with Erskine Caldwell's *God's Little Acre*, which went through 20 printings in one year, selling approximately 3 million copies in 1947 alone. It continued this success with other Caldwell books as well as endless Mike Hammer titles by Mickey Spillane, living up to its motto "Good Reading for the Millions." In 1955, Dell had its first million-seller, *Bonjour Tristesse* by Françoise Sagan, followed the next year by Grace Metalious's *Peyton Place*, which ultimately sold around 14 million copies. Overall, Dell sold an estimated 11 million books between 1943 and 1945, for a total of 25 million by the decade's end. Even so, it came in third place behind Pocket Books, at 50 million, and Bantam and New American Library, tied at 30 million each. Avon placed fourth with 14 million—still a staggering figure.

In the 1950s, new literary trends emerged. Many of the Beat writers found their way into paperback, especially Jack Kerouac (1922–1969). *Junkie: Confessions of an Unredeemed Drug Addict*, the first published work by William S. Burroughs (1914–1997), appeared in 1953 as an Ace Double under the nom de plume William Lee. *Howl*, the seminal work by Allen Ginsberg (1926–1997), was published in a "Pocket Poets Series" by City Lights Books in 1956. However, the industry soon trivialized the Beat phenomenon with such titles as *Beat, Beat, Beat* (a collection of cartoons), *Sintime Beatniks*, *Beatnik Wanton*, *Jesus Was a Beatnik*, and *Like Crazy, Man*.

Another newly minted genre was "JD," covering juvenile delinquent fiction and nonfiction alike. This quickly spilled onto the Hollywood screen, with film adaptations of novels like *The Blackboard Jungle* by Evan Hunter (1926–2005), and original screenplays penned by paperback authors, including *Rebel Without a Cause* by Irving Shulman (1913–1995), whose novel, *The Amboy Dukes*, kicked off the whole genre in 1949. Coinciding with the birth of rock and roll in 1954, the rebellious youth market was at once vilified and pandered to.

The explosion of science fiction introduced the world to the works of Isaac Asimov, Ray Bradbury, Robert Silverberg, L. Ron Hubbard, and their ilk. Philip K. Dick's *Solar Lottery*, his first published novel, was a paperback original from Ace in 1955. This manner of success was repeated in the 1960s with Kurt Vonnegut's *The Sirens of Titan*, first published by Dell in 1959. These two books represent a coming full circle of sorts, inasmuch as they both first appeared in paperback, and were later picked up by hardcover publishers

and reprinted in cloth editions. Today, Stephen King is among the writers who continue to prosper in both hard and soft covers.

Still, with so many publishers entering the market, the industry was bound to suffer. Publishers continued with large print runs even as the competition grew. Remainders, or unsold books that could be peddled cheaply in large lots, became commonplace. Since the shipping cost for returning these books was so great, the industry practice became simply to return the covers to the publisher for a credit and destroy the rest. This eventually led to two forms of fraud: first, counterfeit covers that were printed and sent in for a cash credit; and second, books that were sold minus their covers, even as those covers were returned for a full refund.

By the mid-1950s, there was an enormous surplus of unsold and returned paperbacks stored in the warehouses of various publishers. It is estimated that as many as 60 million copies were unceremoniously destroyed. Pocket Books, in particular, did so by burying them in an abandoned canal outside of Buffalo, New York. The fervor for censorship inspired by Senator Joseph McCarthy also took its toll, both on content and packaging. The absurdity of the list of books deemed obscene by the Select Committee on Current Pornographic Materials speaks for itself: *Young Lonigan* by James T. Farrell, *The Wayward Bus* by John Steinbeck, *God's Little Acre* by Erskine Caldwell, and *The Snow Was Black* by George Simenon. Even so, the Postmaster General was given increased powers to save the public from "immoral, offensive, and otherwise undesirable matter," resulting in industry-wide self-censorship akin to the self-enforced code in the comics industry.

By the end of the 1960s, the heyday of the mass-market paperback was reaching its end—at least as a barometer of culture, if not in sales. The move toward more photographic and sedate, large-type covers no doubt played its part; television, the Vietnam War, and a decline in reading in general added to the mix. In the 1970s and 1980s, new printing techniques were introduced, and publishers tried to regain lost ground. Embossing, debossing, Day-Glo inks, foil stamping, and die cuts all became synonymous with the mass-market paperback, ironically replacing one form of kitschy, lurid cover with another. Today, mention a mass-market paperback and what comes to mind is still something akin to the supermarket tabloids screaming for your attention as you roll by with a shopping cart. Sadly, paperbacks maintain their lowly position in the pantheon of American culture—still a guilty pleasure that can be quickly hidden inside a purse or jacket pocket.

D1199

SIGNET
50¢
DOUBLE
VOLUME

An Unforgettable
Gallery of Characters

By America's
Most Popular Author

The Complete Stories of

Erskine
Caldwell

A SIGNET DOUBLE VOLUME
Complete and Unabridged

A Novel Approach

Charles and Albert Boni were the first to publish paperbacks in the United States, starting with a mail-order book club in 1929 and then a short time later as BoniBooks, which sold them to the general public. Noted artist Rockwell Kent designed the handsome editions. Unfortunately, BoniBooks soon succumbed to the Depression and ceased publishing in 1932. That same year, the National Home Library Foundation in Washington, D.C., produced a series of classics under the Jacket Library imprint. These too proved short-lived.

Often cited as the first mass-market paperback in the U.S., *The Postman Always Rings Twice* by James M. Cain was published by Mercury Publications in 1937. The typography, logo, and cover design were all the work of the German-born George Salter, who emigrated here in 1934. However, the Mercury books were printed digest-size, wider than what we have come to know as the mass-market paperback, with two columns of type on each page.

The following year saw the publication of the Pulitzer Prize–winning *The Good Earth* by Pearl S. Buck, who was on the way to being awarded the Nobel Prize in literature that same year. Generally considered the first true American paperback, it was published by Robert de Graff as a test for his Pocket Books imprint. Now anyone could afford literature, at a fraction of the cost of a hardcover. And so the format of the "pocket book" was born. Still, it took the publishing houses a while to find their footing in terms of design, at first offering European-influenced covers— flat, graphic, airbrushed, and poster-like—by such artists as Robert Jonas and E. McKnight Kauffer.

James Avati helped usher in the paperback's signature look of lurid realism for Signet Books, beginning with *Last of the Conquerors* in 1948. He produced dozens of covers for both New American Library, which owned Signet, and (starting in 1950) Bantam as well. Many of his Signet pieces were new covers for previously printed editions that had featured art by Jonas. The shift in approach proved quite successful, and soon many other artists had begun to imitate Avati's dark, emotional style.

Avati was so successful that he was offered the job of art director at Signet, which he turned down. Heavily influenced by the films he had watched as a child, Avati painted in oil from photographs taken by himself, both of professional models and people he knew, working out of a studio in Red Bank, New Jersey. He painted covers for authors as diverse as Pearl

S. Buck, Erskine Caldwell, Theodore Dreiser, James T. Farrell, William Faulkner, Erle Stanley Gardner, Alberto Moravia, James Michener, John O'Hara, J. D. Salinger, and Mickey Spillane. Often called the "Rembrandt of Paperback Book Covers," Avati's influence was immense. Fellow cover artist and studio mate Stanley Meltzoff once said: "Avati stands alone, not only as a great pioneer but as the best of us, right up to today. He is the only one who counts—everyone else just passed through."

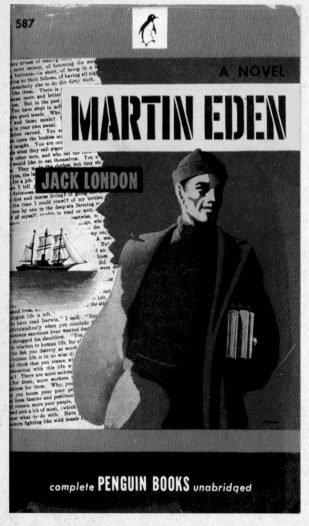

PREVIOUS SPREAD: Signet Books, New York 1955. Artist: James Avati
ABOVE AND OPPOSITE: Penguin Books, New York, 1946, 1947. Artist: Robert Jonas

643

YOUNG LONIGAN

JAMES T. FARRELL

the first
of the
Studs Lonigan
novels

complete **PENGUIN BOOKS** unabridged

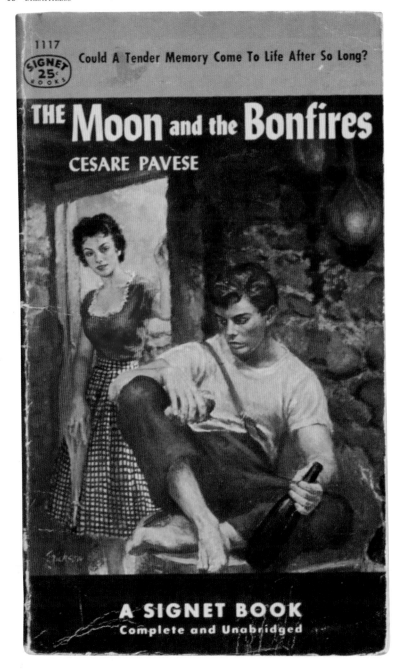

1117

Could A Tender Memory Come To Life After So Long?

SIGNET 25c BOOKS

THE Moon and the Bonfires

CESARE PAVESE

A SIGNET BOOK
Complete and Unabridged

ABOVE: Signet Books, New York, 1954. Artist: George T. Erickson
OPPOSITE: Signet Books, New York, 1954. Artist: James Avati

S1079

35¢

William Faulkner
Two Complete Full-Length Novels

SANCTUARY *and*
REQUIEM FOR A NUN

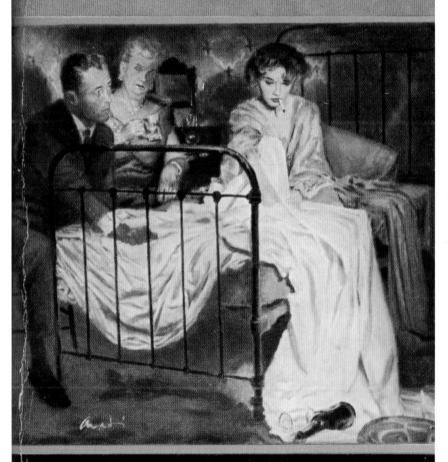

A SIGNET GIANT
Complete and Unabridged

958

N.A.L
SIGNET
BOOKS

A Throbbing Novel of Innocence and Evil
By the author of *Meg*

The Double Door

Theodora Keogh

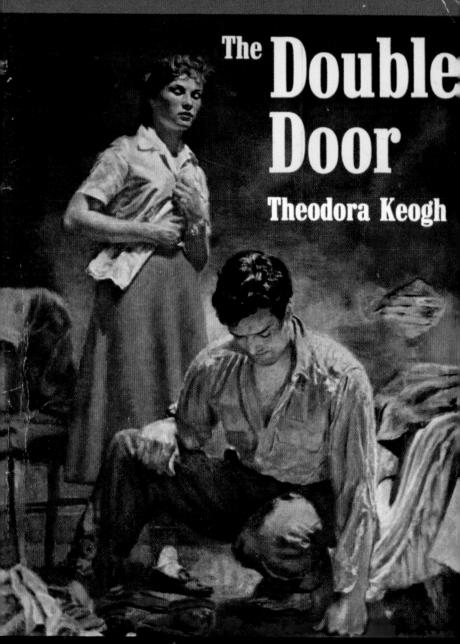

A SIGNET BOOK
Complete and Unabridged

D 967

SIGNET
50¢
DOUBLE
VOLUME

A Great Novel That Reveals the
Innermost Secrets of a Woman's Life

Lie Down in Darkness

WILLIAM STYRON

A SIGNET DOUBLE VOLUME
Complete and Unabridged

OPPOSITE AND ABOVE: Signet Books, New York, 1952. Artist: James Avati

By the Author of "Sanctuary"

INTRUDER IN THE DUST

WILLIAM FAULKNER

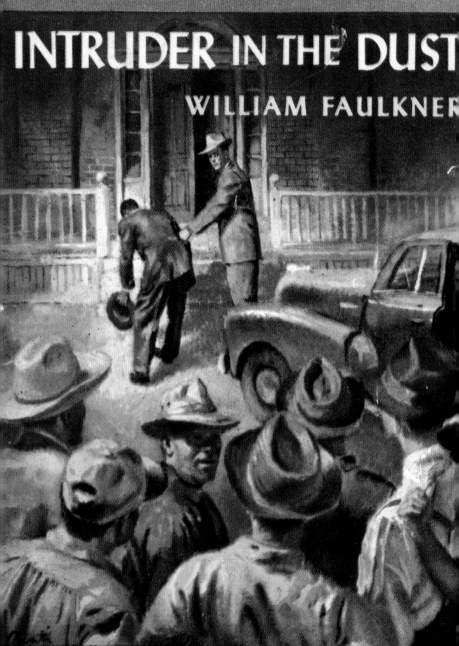

SIGNET BOOKS
Complete and Unabridged

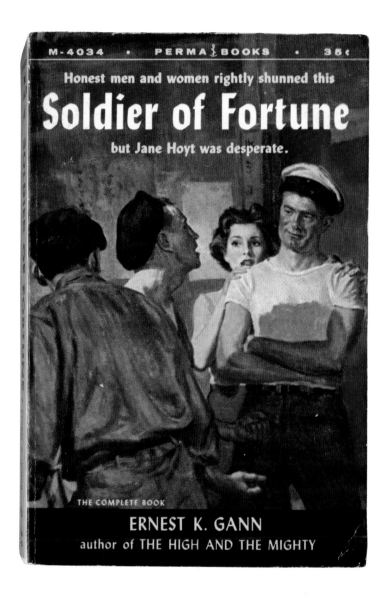

OPPOSITE: Signet Books, New York, 1949. Artist: James Avati
ABOVE: Perma Books, New York, 1955

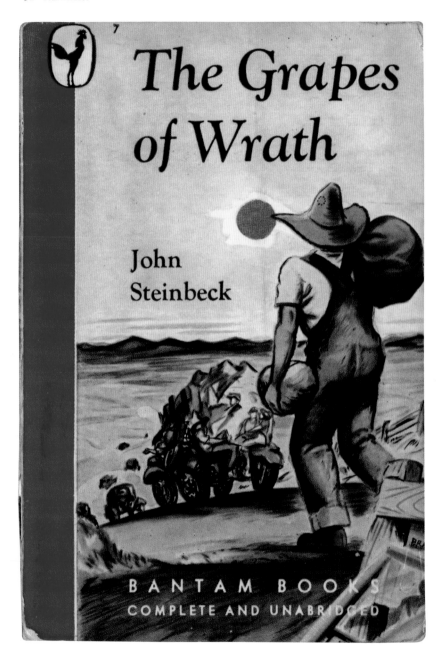

ABOVE: Bantam Books, New York, 1945
OPPOSITE: Pocket Books, New York, 1953. Artist: Tom Dunn

939

POCKET BOOK

25¢

THE
COMPLETE
BOOK

The Sundowners

Their home was a wagon by day
and a tent by night

JON
CLEARY

POCKET
BOOKS
INC.

ABOVE: Crest Books, New York, 1958. Artist: Barye Phillips
OPPOSITE: Bantam Books, New York, 1947

1266

BANTAM
BOOKS

25¢

STEINBECK

Cannery Row

John Steinbeck's Biggest Best Seller—
OVER 2,000,000 COPIES SOLD

COMPLETE AND UNABRIDGED

JOHN STEINBECK

Pulitzer Prize-Winning Author
of *East of Eden* and
The Wayward Bus

TORTILLA FLAT

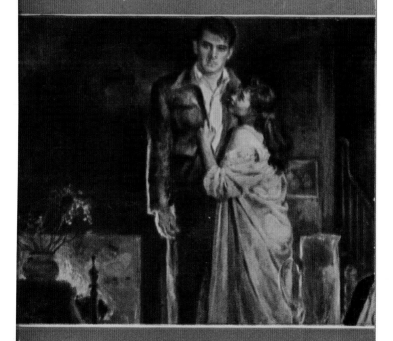

OPPOSITE: Signet Books, New York, 1946. ABOVE: Signet Books, New York, 1953

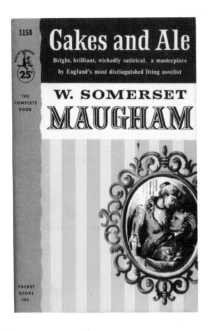

ABOVE, CLOCKWISE: Pocket Books, New York 1957, Artist: Leo Manso. Signet Books, New York, 1953. Bantam Books, New York, 1948. OPPOSITE: Signet Books, New York, 1953. Artist: James Avati

D1667

SIGNET BOOKS 50¢

J. D. SALINGER

THE Catcher IN THE Rye

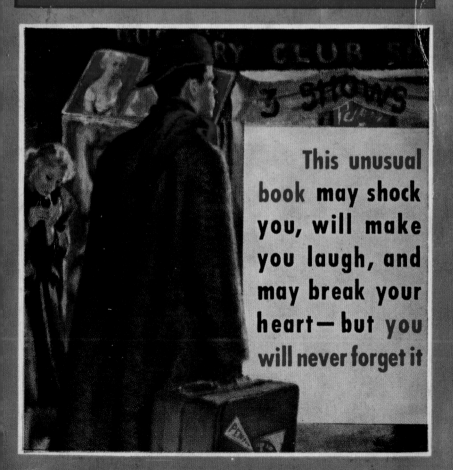

This unusual book may shock you, will make you laugh, and may break your heart— but you will never forget it

A SIGNET BOOK Complete and Unabridged

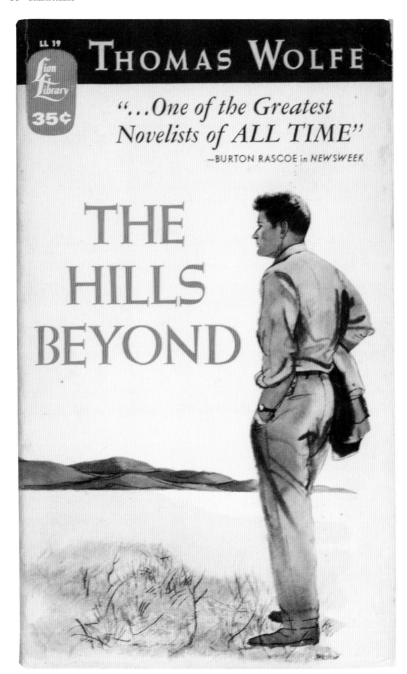

Lion Library, New York, 1955

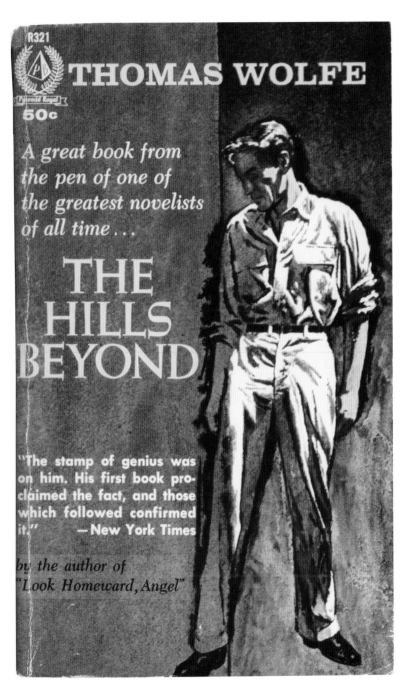

Pyramid Books, New York, 1958. Artist: Harry Schaare

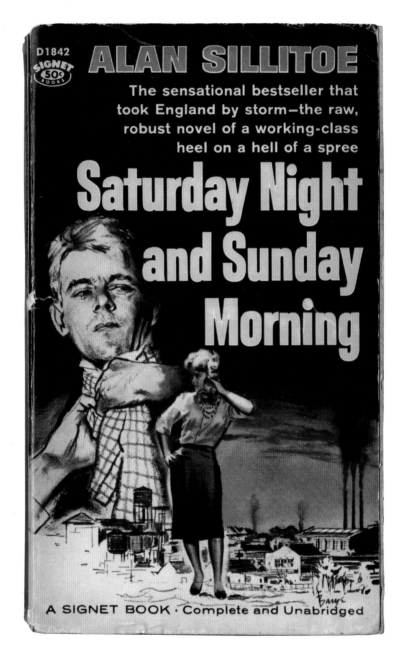

ABOVE: Signet Books, New York, 1960. Artist: Barye Phillips
OPPOSITE: Cardinal Edition, New York, 1961

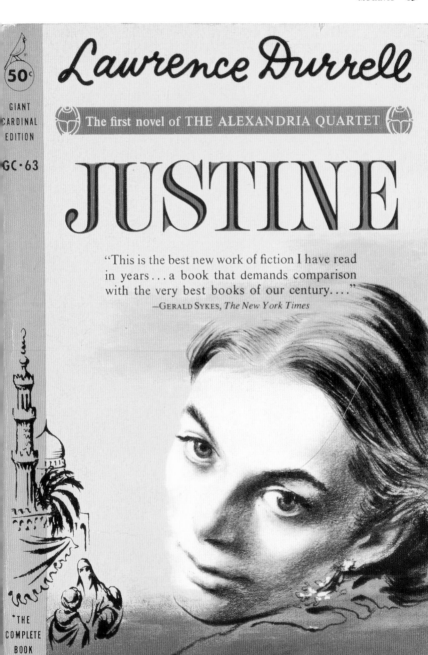

Lawrence Durrell

50¢

GIANT
CARDINAL
EDITION

GC·63

The first novel of THE ALEXANDRIA QUARTET

JUSTINE

"This is the best new work of fiction I have read in years...a book that demands comparison with the very best books of our century...."
—GERALD SYKES, *The New York Times*

*THE COMPLETE BOOK

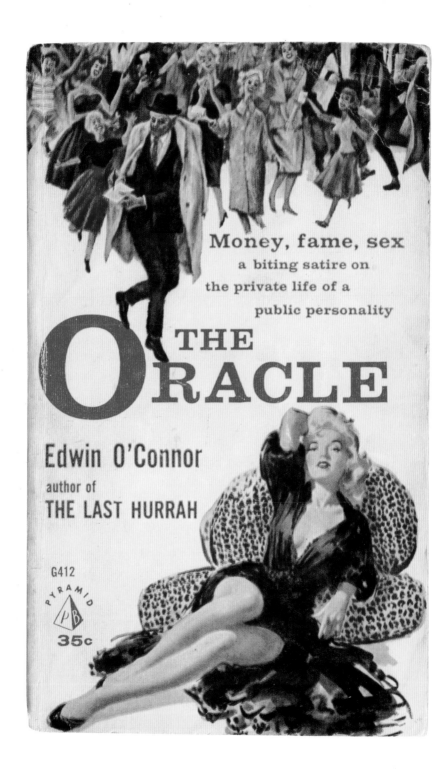

Money, fame, sex
a biting satire on
the private life of a
public personality

THE ORACLE

Edwin O'Connor
author of
THE LAST HURRAH

G412

PYRAMID

35c

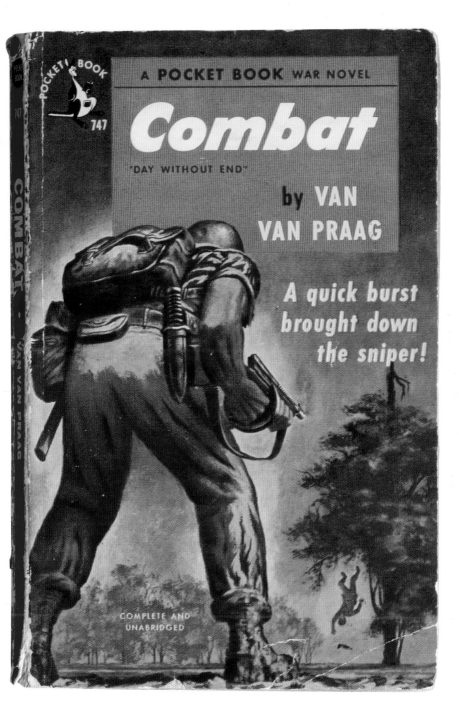

A POCKET BOOK WAR NOVEL

Combat

"DAY WITHOUT END"

by VAN
VAN PRAAG

A quick burst
brought down
the sniper!

747

COMPLETE AND
UNABRIDGED

OPPOSITE: Pyramid Books, New York, 1959. Artists: Robert Maguire and Bob Engle
ABOVE: Pocket Books, New York, 1950. Artist: Lew Keller

A LION ORIGINAL

25c

SHE LED A MARRIED MAN TO SHOCKING DEPTHS

EVIL ROOTS

Walter
Untermeyer, Jr.

222

042

SIGNET
25¢
BOOKS

THE Red Carnation

ELIO VITTORINI

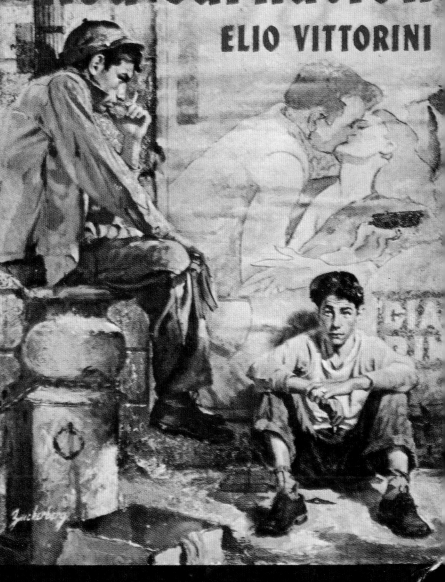

A SIGNET BOOK
Complete and Unabridged

TOPPER

A RIBALD ADVENTURE, BY
THORNE SMITH

COMPLETE AND UNABRIDGED

Pocket BOOK · EDITION

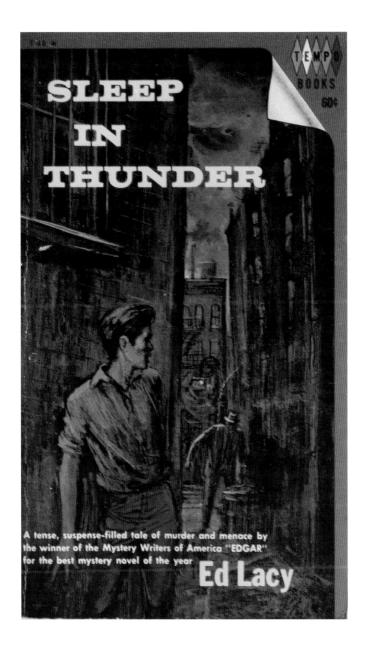

PREVIOUS SPREAD, FROM LEFT: Lion Books, New York, 1954. Signet Books, New York, 1953. Artist: Stanley Zuckerberg. OPPOSITE: Pocket Books, New York, 1939. ABOVE: Tempo Books, New York, 1964

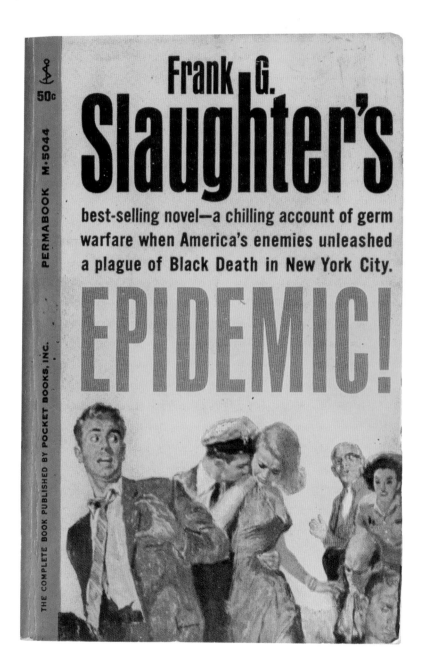

ABOVE: Perma Books, New York, 1962. OPPOSITE: Signet Books, New York, 1977. Artist: Paul Bacon

SIGNET • 451-AE3296 • (CANADA $4.95) • U.S. $3.95

COMA

A NOVEL BY

ROBIN COOK

AUTHOR OF

MINDBEND

THE #1 MEDICAL THRILLER OF THE YEAR..."GRIPPING, TERRIFYING, FAST-PACED SUSPENSE!" — NEW YORK TIMES

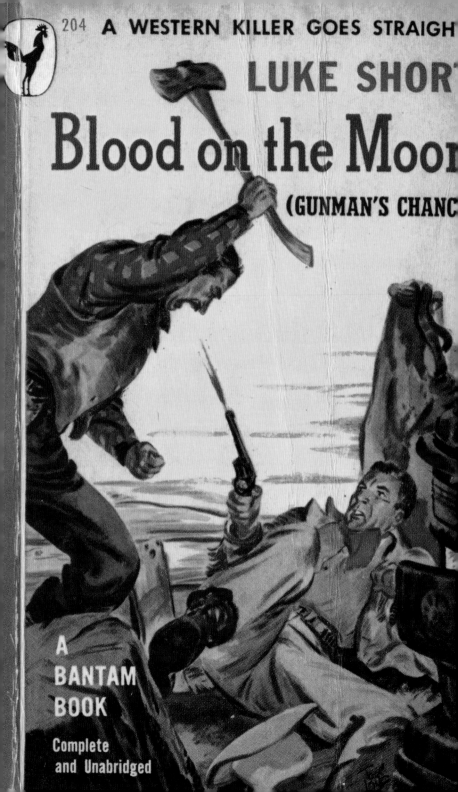

204 A WESTERN KILLER GOES STRAIGHT

LUKE SHORT

Blood on the Moon

(GUNMAN'S CHANCE)

A BANTAM BOOK

Complete and Unabridged

Wild and Wicked

Starting with the "penny dreadfuls" and "dime novels" of the mid–19th century (as well as the works of James Fenimore Cooper), the Western proved to be one of the most popular and enduring genres. By the turn of the century, pulp magazines had taken it over, and the Western was readily adapted to paperbacks as well. Owen Wister, Zane Grey, and Max Brand led the way, their popularity no doubt enhanced by Western movies. Artists such as newcomer Frank McCarthy and pulp alumni A. Leslie Ross and Norman Saunders provided eye-catching, action-packed painted covers. Bantam dedicated as much as one quarter of its list to Westerns in the 1940s and early 1950s.

OPPOSITE: Bantam Books, New York 1948. Detail from *Free Grass*, Popular Library, New York, 1953

25¢

AVON

507

Bloody Guns Roar in Outlaw Valley

STRAW BOSS

E. E. HALLERAN

COMPLETE AND UNABRIDGED

HOT LEAD FOR BEEF RUSTLERS

180

Wild West

BERTRAND W. SINCLAIR

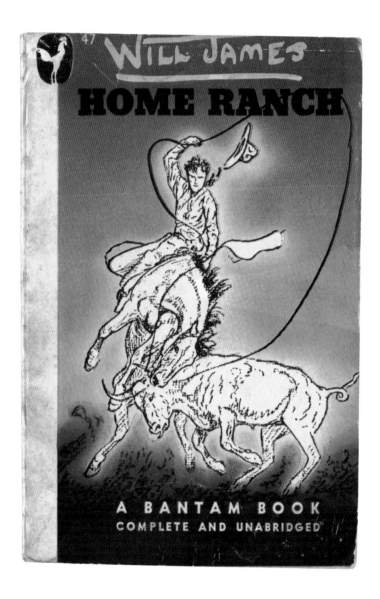

PREVIOUS SPREAD, FROM LEFT: Avon Books, New York, 1952.
Popular Library, New York, 1946

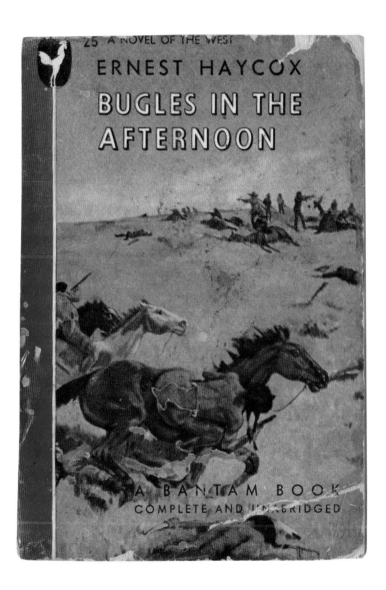

OPPOSITE: Bantam Books, New York, 1946. Artist: Will James
ABOVE: Bantam Books, New York, 1946

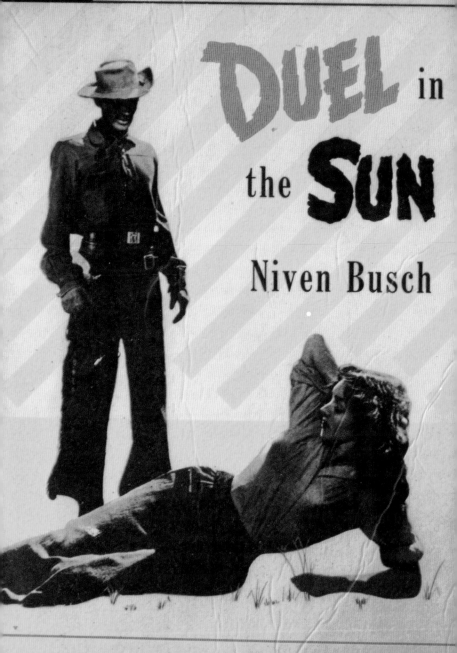

POPULAR LIBRARY

A LUSTY NOVEL OF THE SOUTHWE

Duel in the Sun

Niven Busch

THE DRAMATIC NOVEL FROM WHICH THE SELZNIC
TECHNICOLOR FILM EPIC WAS MADE, STARRIN
JENNIFER JONES · JOSEPH COTTEN · GREGORY PEC

POPULAR LIBRARY

BULLET LAW HITS A RENEGADE TOWN

184

MARSHAL of Sundown

JACKSON GREGORY

OPPOSITE AND ABOVE: Popular Library, New York, 1946.
Popular Library, New York, 1946

"...it is a fine story as are all of his other stories..."
—ERNEST HEMINGWAY

LONE STAR

35¢

ANC

By John W. Thomason, Jr.

PREACHER

BERKLEY
BOOKS
G-10

COMPLETE AND UNABRIDGED

Berkley Books, New York, 1955. Artist: Harry Schaare

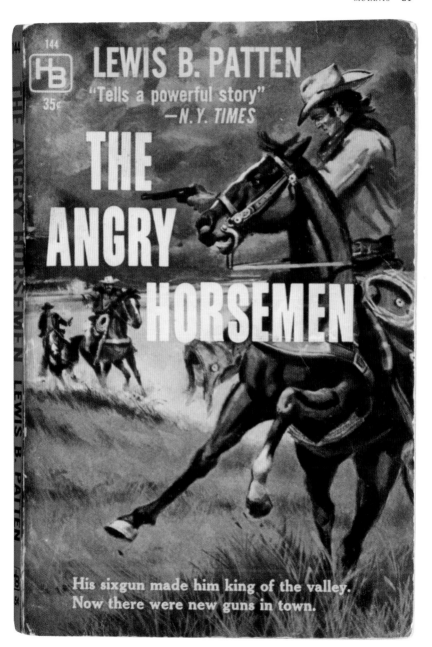

Hillman Books, New York, 1960

Dell Books, New York, 1939. Artist: F. Kenwood Giles

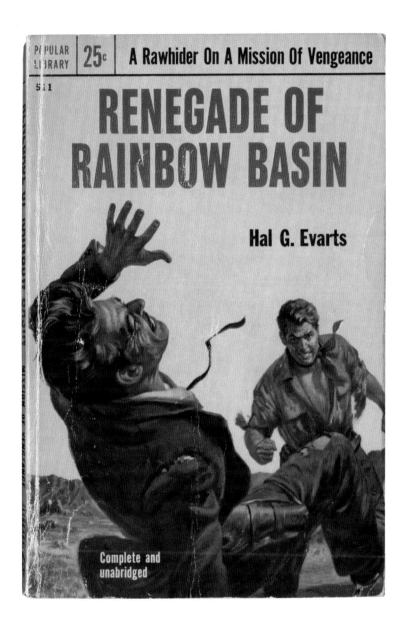

Popular Library, New York, 1953

ABOVE: Signet Books, New York, 1951
BOTTOM: Detail from the back cover of *Tiger Roan*, Pocket Books, Jr., 1950. Artist: Sam Savitt. OPPOSITE: Ace Books, New York, 1970

ce
ouble
11785 60¢

Trouble Valley

LOUIS TRIMBLE

Choose — between dynamite or a run-out powder!

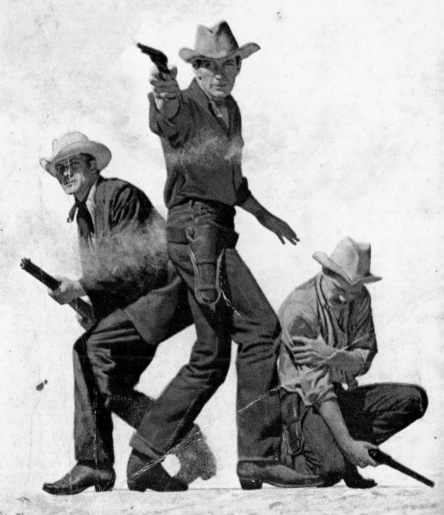

1005

A Range Detective Rides for Vengeance

BLIND CARTRIDGES

WILLIAM COLT MacDONALD

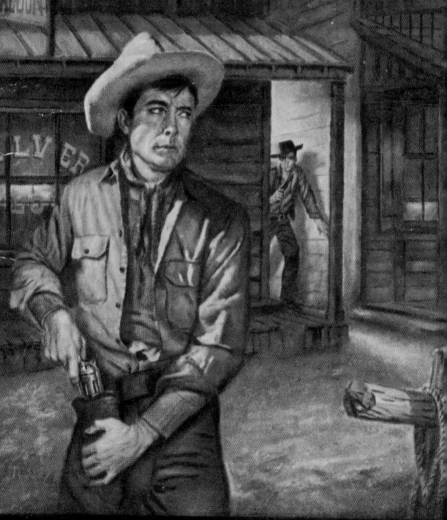

A SIGNET BOOK

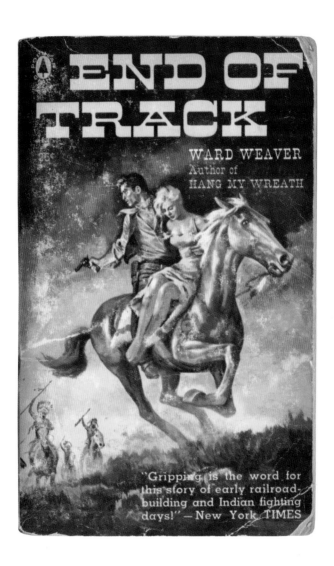

OPPOSITE: Signet Books, New York, 1953. Artist: Vern Tossey
ABOVE: Popular Library, New York, 1959

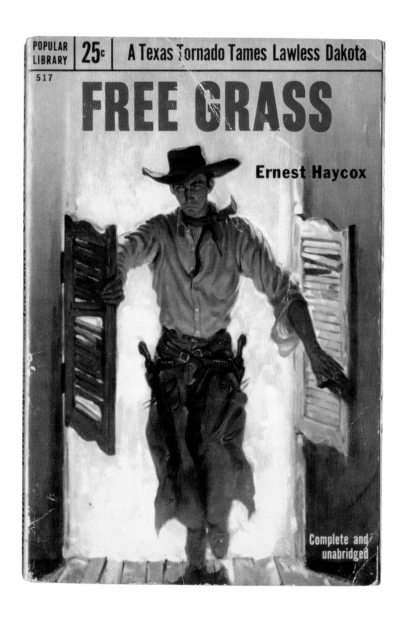

POPULAR LIBRARY
517
25¢
A Texas Tornado Tames Lawless Dakota
FREE GRASS
Ernest Haycox
Complete and unabridged

Popular Library, New York, 1953

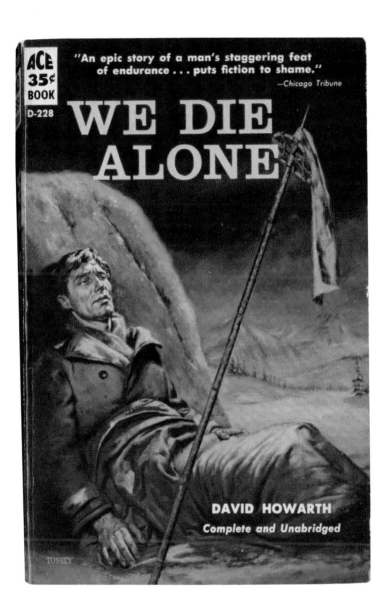

ABOVE: Ace Books, New York, 1953. FOLLOWING SPREAD:
Dell Books, New York, 1948. Artist: Bob Stanley

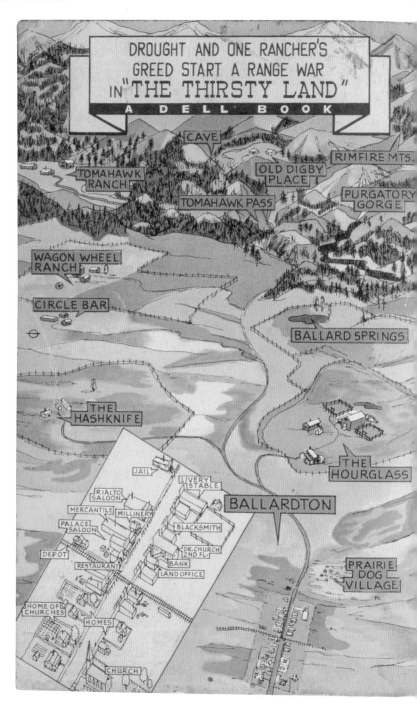

DROUGHT AND ONE RANCHER'S
GREED START A RANGE WAR
IN "THE THIRSTY LAND"
A DELL BOOK

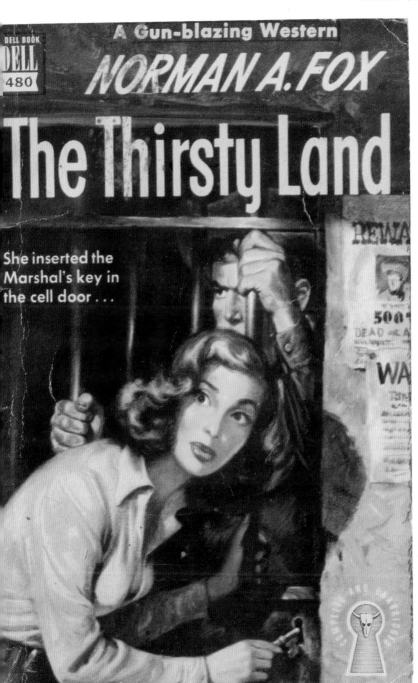

A Gun-blazing Western

DELL BOOK 480

NORMAN A. FOX

The Thirsty Land

She inserted the Marshal's key in the cell door . . .

1028

N·A·L
SiGNET
BOOKS

A Double-crossing Redhead Starts a Range Wa[r]

The SNAKE STOMPER

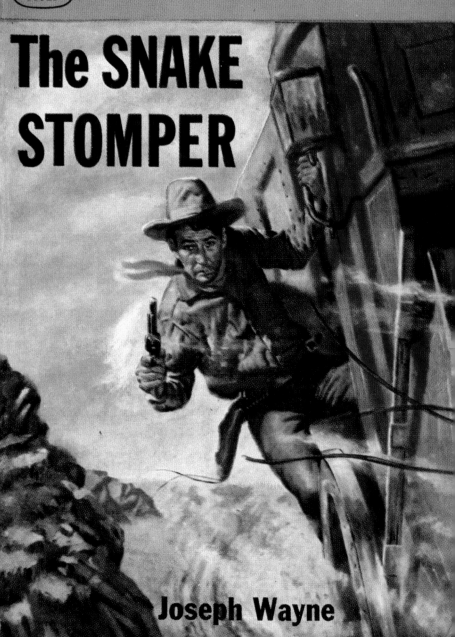

Joseph Wayne

A SIGNET BOOK

Complete and Unabridged

133

BOOK

25c

THE
COMPLETE
BOOK

Galloping Broncos

A WESTERN NOVEL BY Max Brand

POCKET
BOOKS
INC.

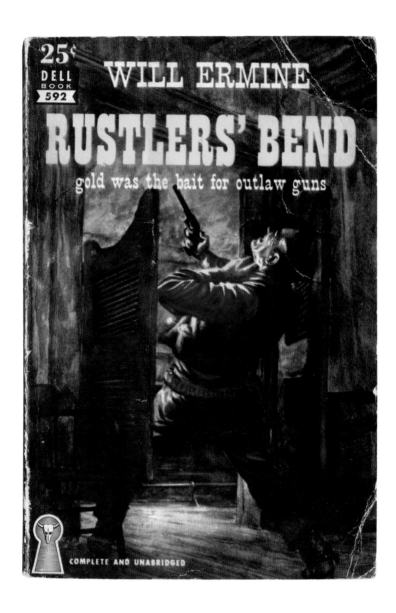

PREVIOUS SPREAD, FROM LEFT: Signet Books, New York, 1953. Artist: Vern Tossey.
Pocket Books, New York, 1956. Artist: Roy Lance
ABOVE: Dell Books, New York, 1949. Artist: Bob Stanley
OPPOSITE: Hillman Books, New York, 1955. Artist: Tom Ryan

William MacLeod Raine

KING OF THE BUSH

5¢

. 36

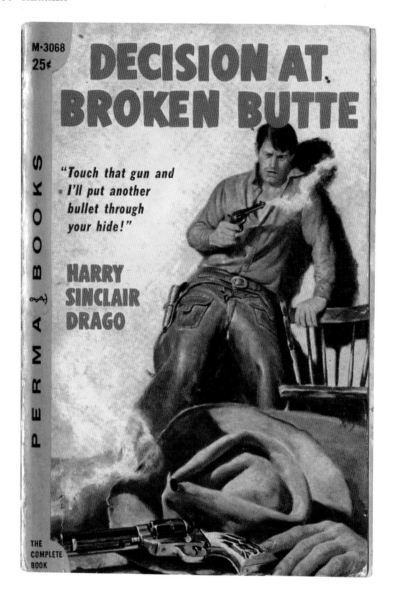

ABOVE: Perma Books, New York, 1957. Artist: Tom Ryan
OPPOSITE: Gold Medal Books, New York, 1955

GOLD MEDAL BOOK

BULLET BARRICADE

25c

He had the careless
courage of a man
who rode with death

**LESLIE
ERNENWEIN**

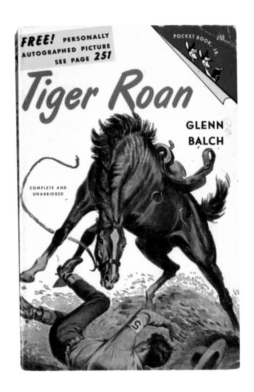

ABOVE: Pocket Books, Jr., 1950. Artist: Sam Savitt
BOTTOM: Detail from the back cover of *Renegade of Rainbow Basin*, Popular Library, New York, 1953

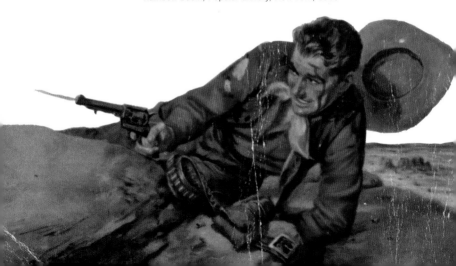

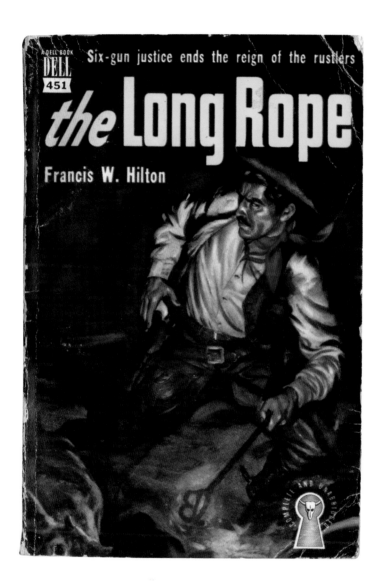

Dell Books, New York, 1950. Artist: Bob Stanley

MEN CALLED HIM BRAVE—
WOMEN, MASTER...

HE knew but three loves...his blazing cannon, his murderous sword—and the woman with whom he set the seas aflame between England and Spain—to save the Queen who had sworn to see him hanged!

For he was a man no nation could claim...La Cacafuego a fiery temptress no Empire would hold. They were outcasts both—whose passions welded a world!

A Great New Historical—A Graphic Giant

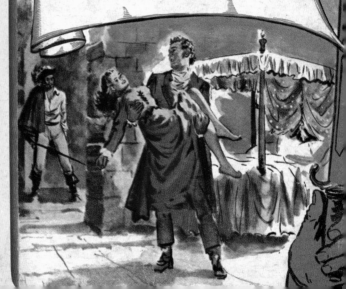

Swords, Sea, and Sky

Swashbuckling tales of pirates, sword fights, buried treasure, and damsels in distress found their way into the paperback early on. Edgar Rice Burroughs's *Tarzan* series proved equally popular. Over time, modern weapons and perils replaced older ones, and Ian Fleming's James Bond series provided a latter-day template for others to follow in the 1950s.

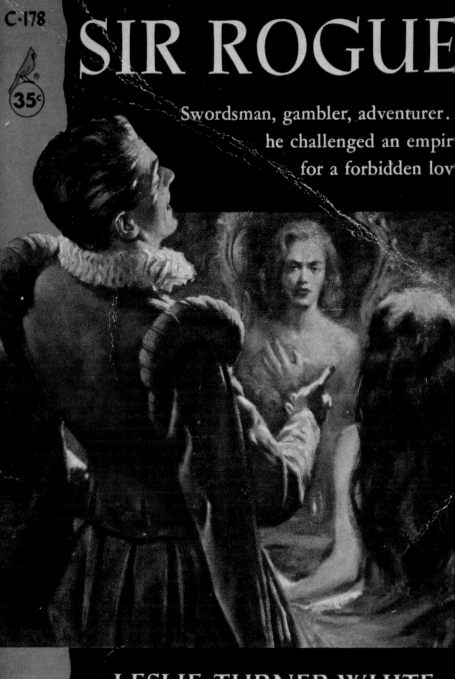

C·178

35¢

SIR ROGUE

Swordsman, gambler, adventurer.
he challenged an empir
for a forbidden lov

LESLIE TURNER WHITE

author of Lord Johnnie, etc.

THE COMPLETE BOOK

A
CARDINAL
EDITION

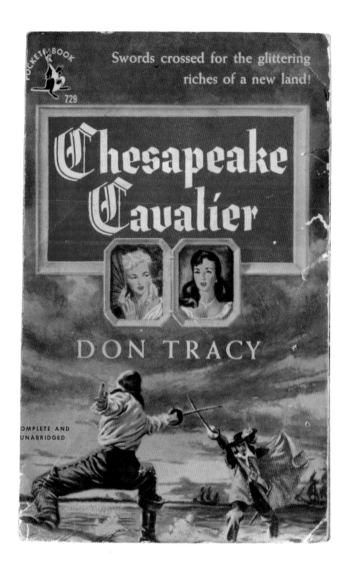

OPPOSITE: Cardinal Editions, New York, 1955. Artist: Clark Hulings
ABOVE: Pocket Books, New York, 1950. Artist: Frank McCarthy

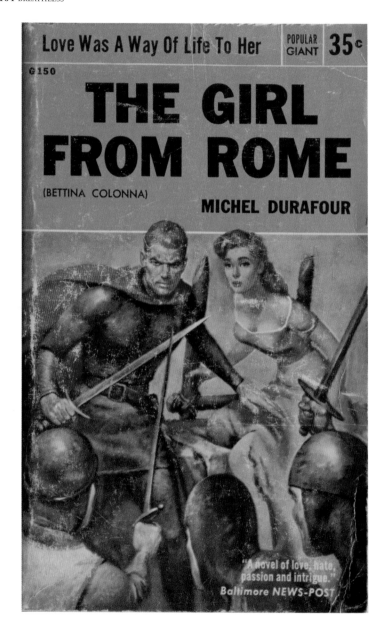

Love Was A Way Of Life To Her

POPULAR GIANT 35¢

G150

THE GIRL FROM ROME

(BETTINA COLONNA)

MICHEL DURAFOUR

"A novel of love, hate, passion and intrigue."
Baltimore NEWS-POST

ABOVE: Popular Library, New York, 1955. OPPOSITE:
Pocket Books, New York, 1956. Artist: Robert Schulz

The most popular and
exciting novel ever written
about survival at sea

MEN AGAINST THE SEA

CHARLES NORDHOFF and
JAMES NORMAN HALL

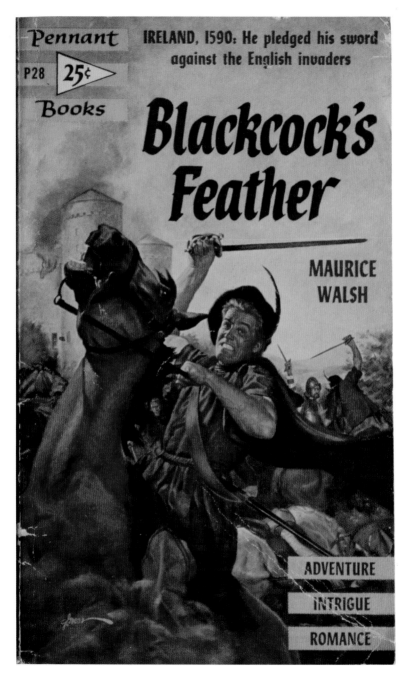

Pennant Books, New York, 1953

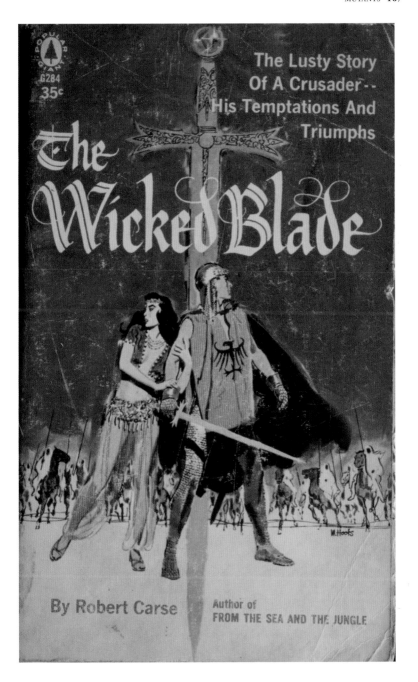

Popular Library, New York, 1958. Artist: Mitchell Hillary Hooks

HE was a captain of horsemen — spearhead of the conquering hordes of Genghis Khan. Three women he loved: a laughing child of the steppes . . . a seductive sister of the gods . . . a princess who yielded him a gift more priceless than empires!

In this sweeping romance, barbarians war for girls and golden cities. Emperors intrigue while concubines preen. And out of the west rides a stranger whose sword shakes the world!

APHIC ANT

G209

35c

THE GOLDEN BLADE

(A Caravan to Camul)

John Clou

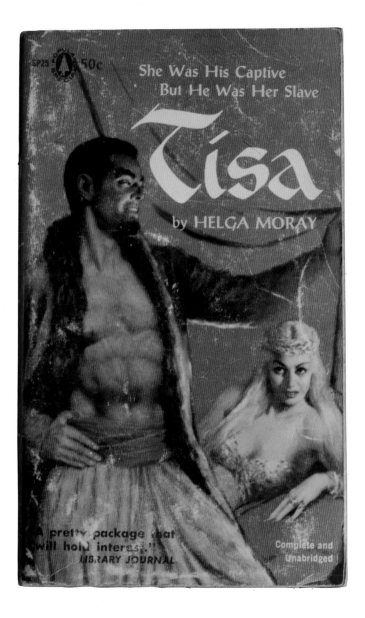

PREVIOUS SPREAD: Graphic Books, Hasbrouck Heights, New Jersey, 1955
ABOVE: Popular Library, New York, 1958
OPPOSITE: Pocket Books, New York, 1951. Artist: Harvey Kidder

KETI-BOOK 819

JAMES STREET

MINGO DABNEY

Death by the *machete!*

Death to the Spaniards!

COMPLETE AND UNABRIDGED

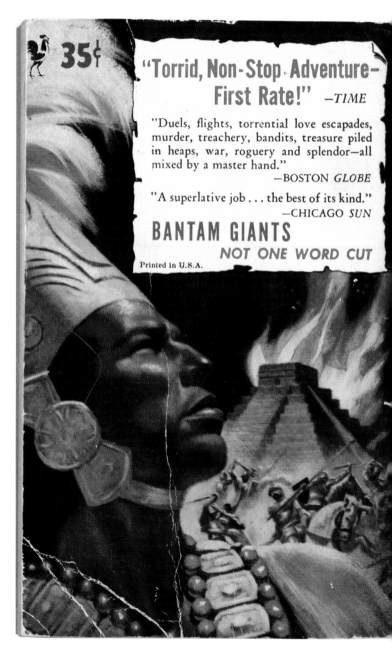

Bantam Books, New York, 1951. Artist: Hy Rubin

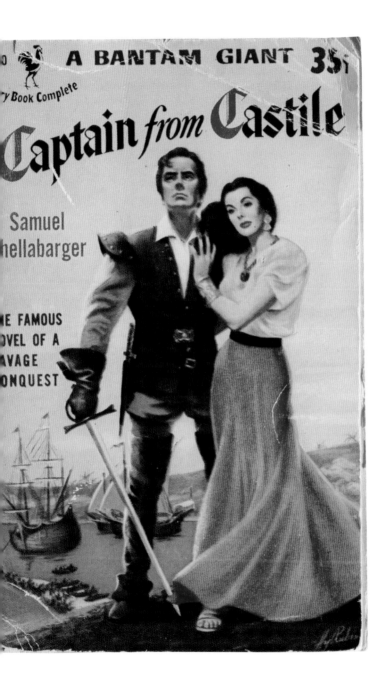

A BANTAM GIANT 35¢

y Book Complete

Captain from Castile

Samuel
hellabarger

HE FAMOUS
OVEL OF A
AVAGE
ONQUEST

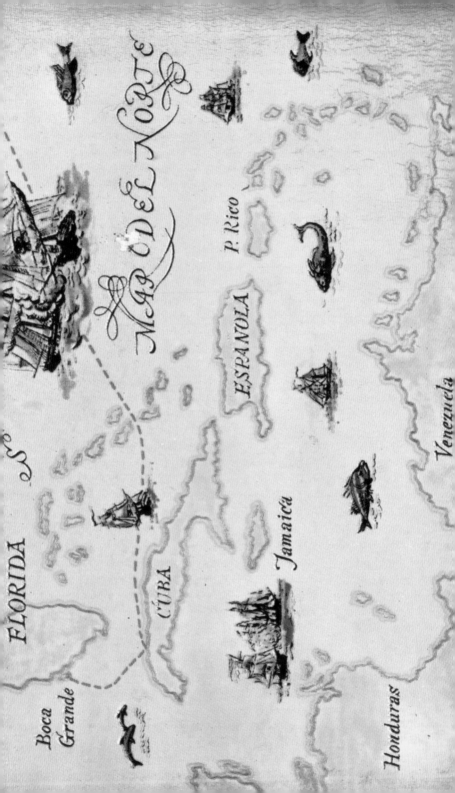

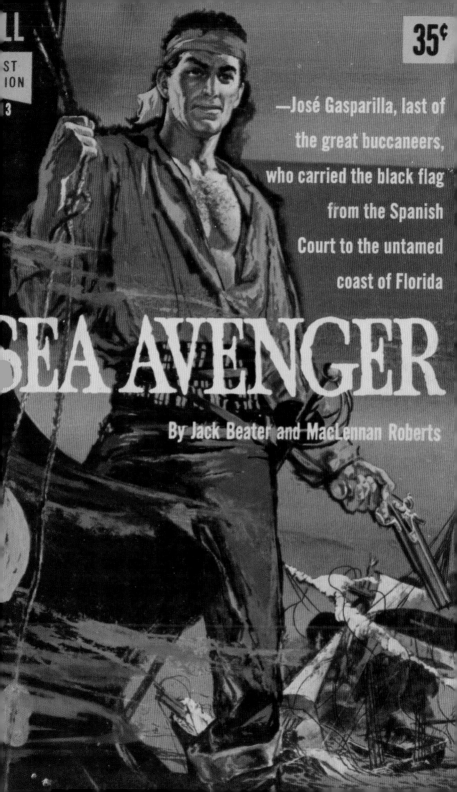

35¢

—José Gasparilla, last of the great buccaneers, who carried the black flag from the Spanish Court to the untamed coast of Florida

SEA AVENGER

By Jack Beater and MacLennan Roberts

AN EPIC DRAMA OF VIOLENT
PASSIONS, HEROIC BATTLES,
LOVES PURE AND IMPURE...

Here is the thrill-packed saga
of Roland and Charlemagne...set
against the background of feudal
France locked in death-struggle
with Moorish Spain.

"STIRRING ... INTENSELY READABLE!"
Saturday Review
"DIFFERENT ... EXCITING ..."
Philadelphia Inquirer

"UNUSUALLY GOOD!"
N. Y. Times

PREVIOUS SPREAD: Dell Books, New York, 1957. Artist: Harry Schaare. ABOVE
AND OPPOSITE: Graphic Books, Hasbrouck Heights, New Jersey, 1953

FOLLOWING SPREAD: Dell Books, New York, 1948. Artist: George Garland. Perma Books, New York, 1956. Artist: Robert Schulz

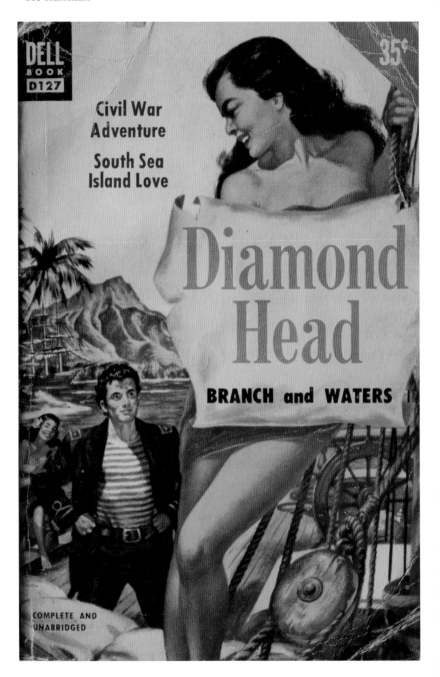

DELL
BOOK
D127

35¢

Civil War
Adventure

South Sea
Island Love

Diamond
Head

BRANCH and WATERS

COMPLETE AND
UNABRIDGED

4067

H.M.S. ULYSSES

"Certainly the best novel of World War II at sea..."

Alistair MacLean

E MPLETE OK

THE TATTOOED MAN

 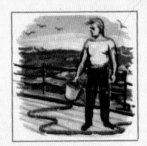

Tod Moran landed himself in the middle of a mystery when he stepped aboard the freighter "Araby." Tod was bound for the Mediterranean in a search for his brother Neil.

He didn't believe that Neil was a thief, and he suspected trouble on the "Araby." What part did sinister Mr. Hawkes play in the conspiracy? Was the Tattooed Man friend or foe?

Finding the answers took Tod through a series of lively adventures, from facing hungry sharks and battling the Black Gang bully to a thrilling escape from a villa near Marseilles

COMET books ROCKEFELLER CENTER, NEW YORK 20, NEW YOR

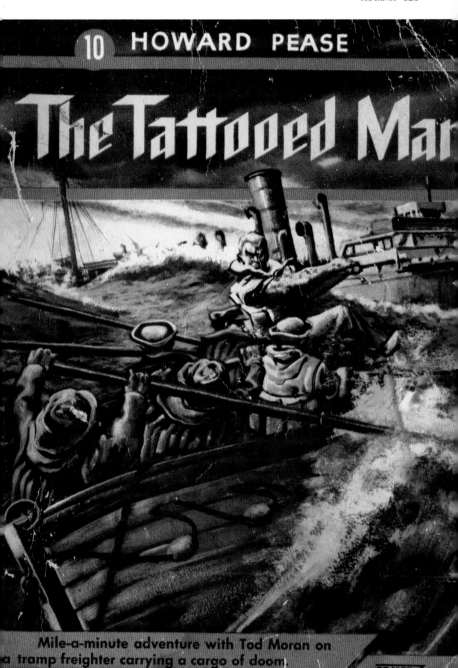

10 HOWARD PEASE

The Tattooed Man

Mile-a-minute adventure with Tod Moran on a tramp freighter carrying a cargo of doom.

COMET books

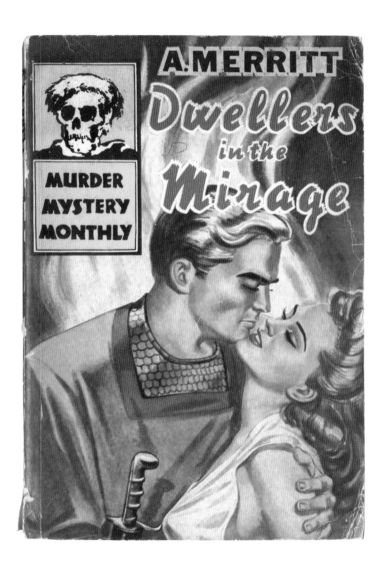

PREVIOUS SPREAD: Comet Books, New York, 1948. Artist: Ralph Ray, Jr.
ABOVE: Liveright Publishing, New York, 1944. OPPOSITE: Perma Books, New York, 1955

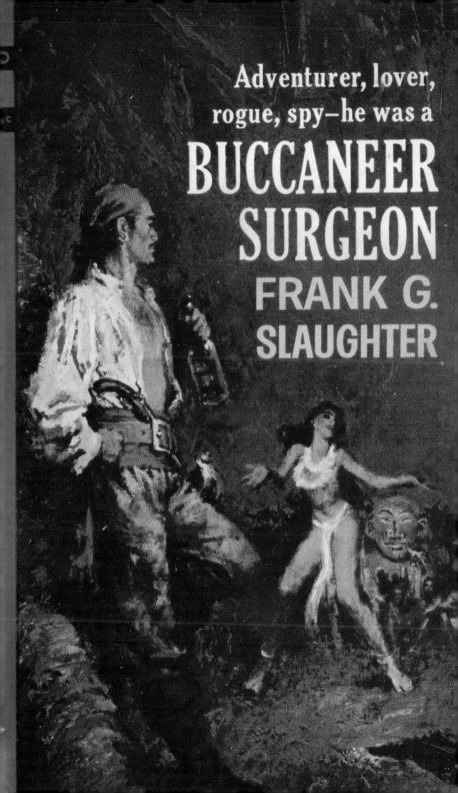

Adventurer, lover, rogue, spy—he was a

BUCCANEER SURGEON

FRANK G. SLAUGHTER

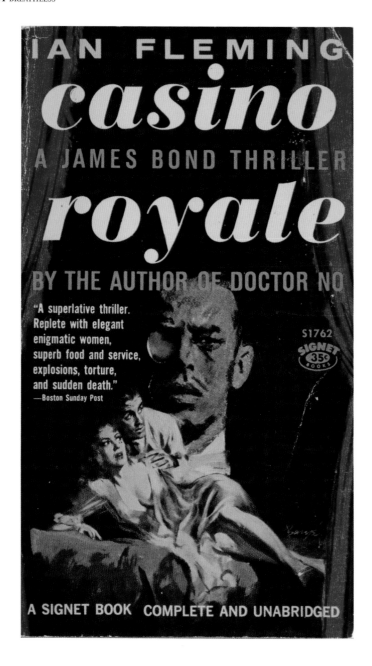

ABOVE: Signet Books, New York, 1960. Artist: Barye Phillips
OPPOSITE: Ace Books, New York, 1962. Artist: Vern Tossey

SCRAMBLE!

Great Novel of an
American Fighter
Squadron

-697

Major MARIO CAPPELLI
U.S.A.F.

Tossy

DELL BOOK

DELL

295

THE GOBLIN MARKET

HELEN McCLOY

WITH CRIME MAP ON BACK COVER

A DELL MYSTERY

Dell Books, New York, 1943. Artist: Gerald Gregg. Detail from *American Gun Mystery*, Avon Books, New York

A Shot in the Dark

The mystery novel was one of the earliest forms of the mass-market paperback. Inheriting the legacy of the pulps, mystery authors such as Agatha Christie, Ellery Queen, and the hardboiled school of Dashiell Hammett, Raymond Chandler, James M. Cain, and others soon found their place in American culture. The term *film noir* was coined by French critic Nino Frank in 1946 to describe the moody American crime films being imported at the time, as well as the paperback novels they were based on (and that inspired books by French writers in the same vein). The covers of these books alternated from airbrushed surrealism to realistic sensationalism, depending on the publishing house. The look of the covers, in large part taken from the pulps, also had much in common with the painted film posters of the day. In fact, some artists like William Rose were lucky enough to work in all three areas.

One of the great innovations of the genre didn't occur on the front cover, but rather on the back. Dell's "mapbacks" displayed a detailed map of the fictional crime scene, instead of blurbs, to help sell its line. Ultimately, these mapbacks were featured on the majority of Dell's first 600 titles. Produced quickly (as many as 5 to 10 titles per month) under the supervision of art director William Strohmer, his assistant George Frederiksen, and leading staff artist Gerald Gregg, Dell's covers boasted an approach to art and design that anticipated postmodernist eclecticism and combined myriad influences: Surrealism, Cubism, European posters, Hollywood movie placards, and airbrushed billboard advertising. The majority of Dell's artists never read the manuscript, working only from the title and a synopsis to paint the covers. Greater attention to detail was bestowed upon the mapbacks by the editors and in-house mapmaker Ruth Belew: They even went so far as to hire local teachers residing in the area covered by the book to identify the locations.

Printed in the U.S.A.

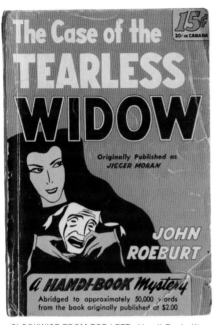

CLOCKWISE FROM TOP LEFT: Handi-Book, Kingston, New York, 1946. Tower Books, New York, 1966. Detective Files, New York, 1954. Handi-Book, 1946, Kingston, New York, 1946
OPPOSITE: Avon Books, New York, 1946

Rex Stout

WHERE THERE'S A WILL

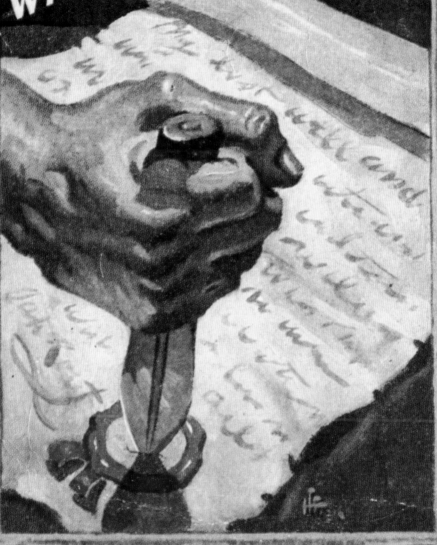

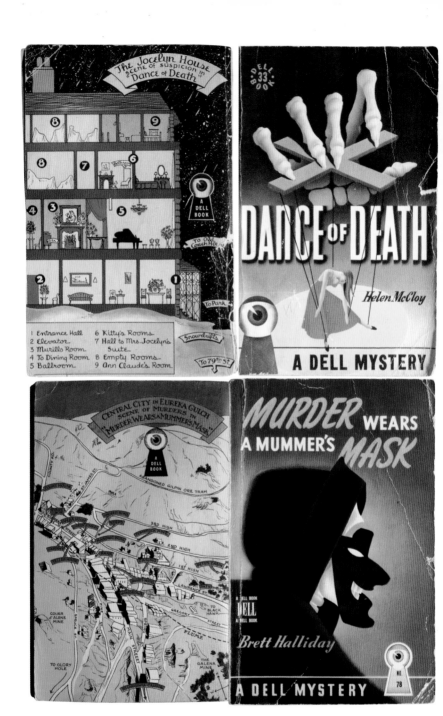

ABOVE: Dell Books, New York, 1938. Artists: Front Covers: Gerald Gregg.
Back Covers: Ruth Belew. OPPOSITE: Bantam Books, New York, 1950. Artist: H. E. Bischoff

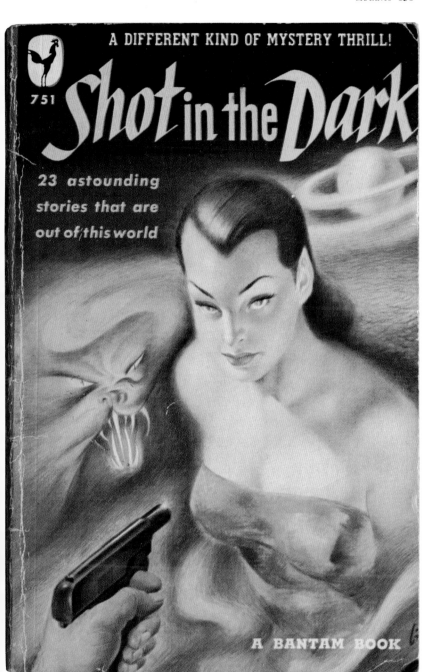

A DIFFERENT KIND OF MYSTERY THRILL!

751

Shot in the Dark

23 astounding stories that are out of this world

A BANTAM BOOK

DELL

968

25¢

He signed up for
a dancing course
and got a free
lesson in murder

The Blonde Died Dancing

By KELLEY ROOS

E.Q. 1933

Ellery Queen

knew who had committed the first murder—
YET HE WAS POWERLESS TO PREVENT
THE SECOND!

AMERICAN GUN MYSTERY

"...the best of the
Ellery Queen books"
—*New York Times*

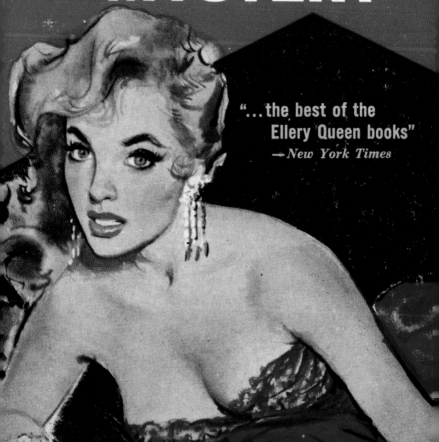

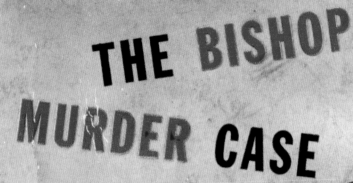

THE BISHOP MURDER CASE

S. S. VAN DINE

Death takes a honeymoon...

A Shot of Murder

JACK IAMS

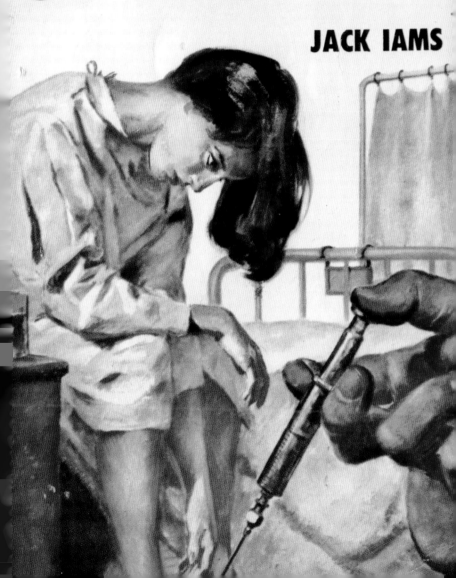

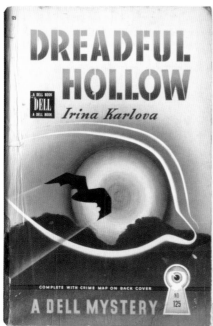

PAGES 132–133: Dell Books, New York, 1956. Artist: Victor Kalin. Avon Books, New York PREVIOUS SPREAD: Pocket Books, New York, 1945. Dell Books, New York, 1953. Artist: Denver Gillen. Dell Books, New York, 1950. Artist: Carl Bobertz. THIS PAGE, FROM TOP: Dell Books, New York, 1942. Artist: Gerald Gregg. OPPOSITE: Graphic Books, New York, 1954

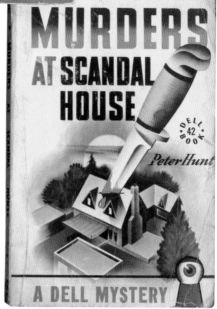

 A GRAPHIC MYSTERY CLASSIC

THE SCARAB
MURDER CASE

S. S. VAN DINE

25

Van Dine
has never
written better

N. Y. Herald Tribune

ABRIDGED
EDITION

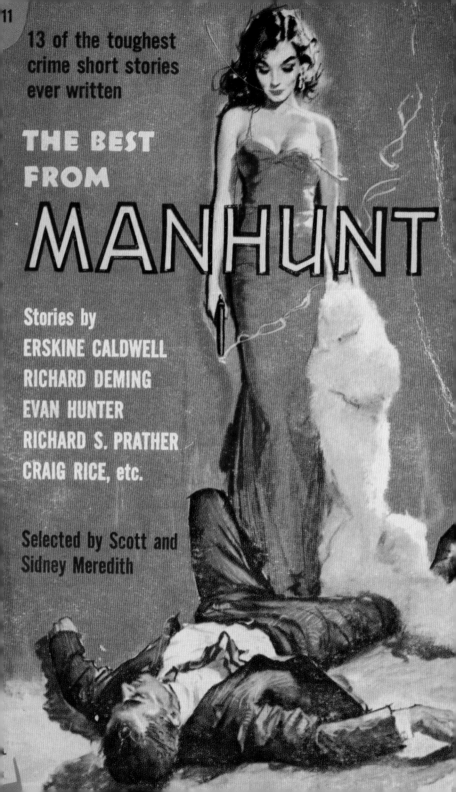

11

13 of the toughest
crime short stories
ever written

THE BEST
FROM

MANHUNT

Stories by
ERSKINE CALDWELL
RICHARD DEMING
EVAN HUNTER
RICHARD S. PRATHER
CRAIG RICE, etc.

Selected by Scott and
Sidney Meredith

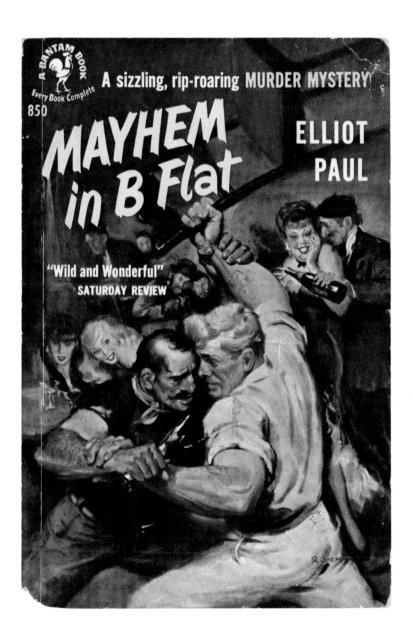

OPPOSITE: Perma Books, New York, 1958. Artist: Ernest Chiriaka
ABOVE: Bantam Books, New York, 1940

BLACK IS THE FASHION FOR DYING

Jonathan Latimer

The most hated prima donna in Hollywood had pushed things too far just once too often!

THE COMPLETE BOOK POCKET BOOK 6087 35¢

PUBLISHED BY POCKET BOOKS, INC. • PRINTED IN U.S.

Caresse Garnet Was a Star on the Skids!

She was poison at the box office and to everyone in Hollywood, but there seemed no way to get rid of her. Even big-time producer "Fatso" Fabro had his hands tied —and hated her for it!

Then there was leading man Ashton Graves, her ex-husband. He was making a comeback—if she'd let him—and one night he had shouted that he'd kill her.

And young Lisa Carson wasn't exactly a Garnet fan either. After six years of bit roles, she'd got her big chance, but the fading vixen was cutting her part to ribbons.

No hearts were broken when Caresse Garnet was murdered. And it looked like the perfect crime. She was shot on a crowded sound stage by two bullets that were supposedly foolproof blanks. And just about everyone in Hollywood was a logical suspect.

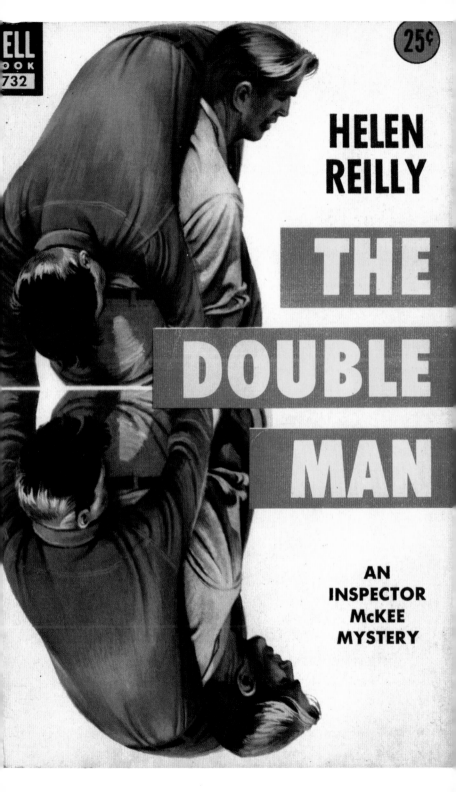

DELL BOOK 732

25¢

HELEN
REILLY

THE
DOUBLE
MAN

AN
INSPECTOR
McKEE
MYSTERY

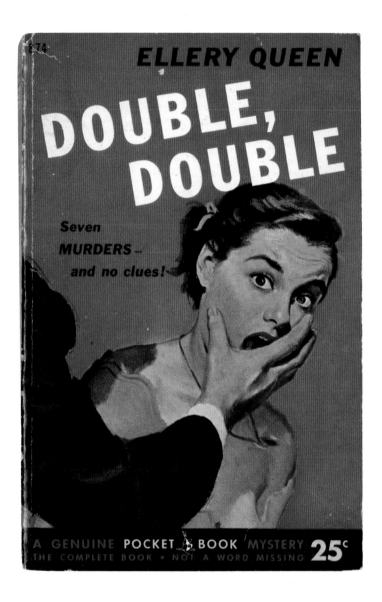

PREVIOUS SPREAD, FROM LEFT: Pocket Books, New York, 1961. Dell Books, New York. ABOVE: Pocket Books, New York, 1952. Artist: Tom Dunn OPPOSITE: Dell Books, New York 1959.

DELL

FIRST EDITION

882

25¢

She was the nicest bad girl in town

Sweet Cheat

by Peter Duncan

ABOVE: Pyramid Books, New York, 1965. OPPOSITE: Lion Books, New York, 1954. Artist: George Gross

A BOLD NOVEL OF MEN AND WOMEN AT WAR

Lion Books

25¢

the
naked
night

DAN BRENNAN

LB 147

25c POPULAR LIBRARY

TAUGHT BY WOMEN

The compassionate tale of two young girls who taught an eager college freshman the meaning of life and love:

Jean, the pretty party girl, who became infatuated with Reid on a blind date. And *Laura,* the lonesome blonde trapped in a brutal marriage, desperately seeking love before time ran out.

"A wonderful story . . . In it Reid Carrington finds physical love with Laura Greene, wife of a fraternity brother, and with Jean King he finds the courage and hope of a love destined to last . . . Richly rewarding."
Buffalo COURIER EXPRESS

PRINTED IN THE UNITED S

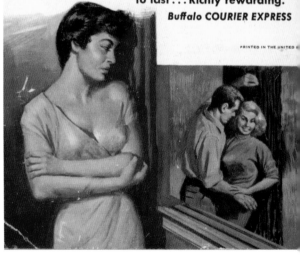

Popular Library, New York, 1955

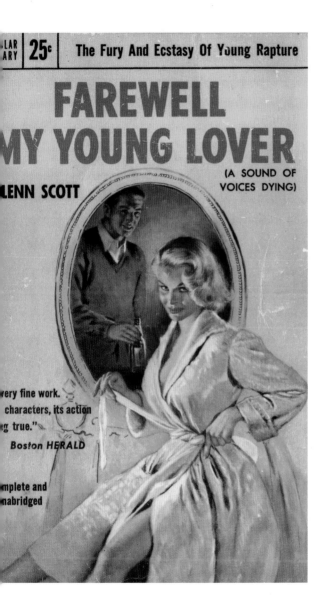

LAR
ARY **25¢** The Fury And Ecstasy Of Young Rapture

FAREWELL
MY YOUNG LOVER
(A SOUND OF
VOICES DYING)

LENN SCOTT

very fine work.
characters, its action
g true."
Boston HERALD

mplete and
nabridged

FOLLOWING SPREAD, FROM LEFT: Dell Books, New York, 1938.
Artist: Gerald Gregg. Pocket Books, New York, 1941

DELL
166

THE WALL

Mary
Roberts
Rinehart

2106

ERLE STANLEY
GARDNER

THE CASE OF THE
LUCKY
LEGS

A
PERRY
MASON
MYSTERY

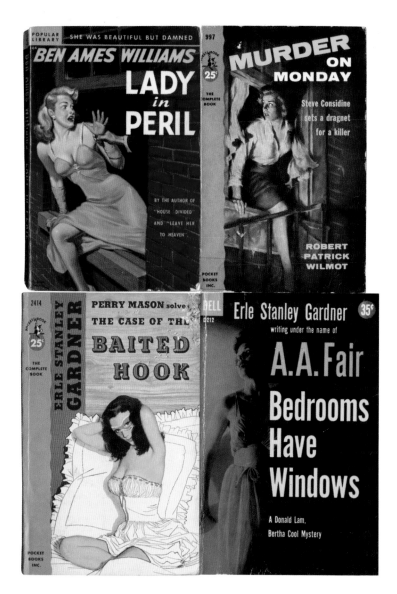

CLOCKWISE FROM TOP LEFT: Popular Library, New York, 1948.
Artist: Rudolph Belarski. Pocket Books, New York, 1954. Artist: George Mayers.
Dell Books, New York, 1958. Pocket Books,New York, 1947. Artist:
Al Moore. OPPOSITE: Pocket Books, New York, 1954. Artist: Arthur Sussman

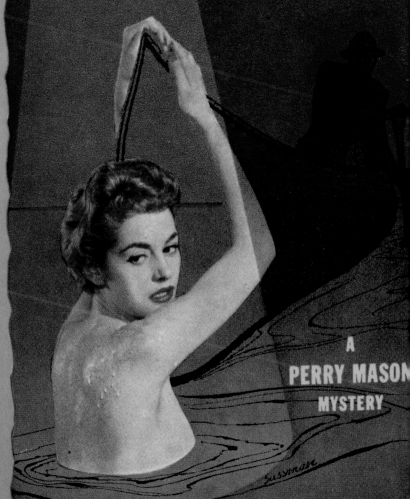

ERLE STANLEY GARDNER

THE CASE OF THE

Negligent Nymph

A
PERRY MASON
MYSTERY

42 A MURDER MYSTERY

LESLIE FORD

ROAD TO FOLLY

A BANTAM BOOK
COMPLETE AND UNABRIDGED

303 COL. PRIMOSE CRACKS A DOUBLE MURDER!

SIREN
in the Night

LESLIE
FORD

A BANTAM BOOK
Complete and Unabridged

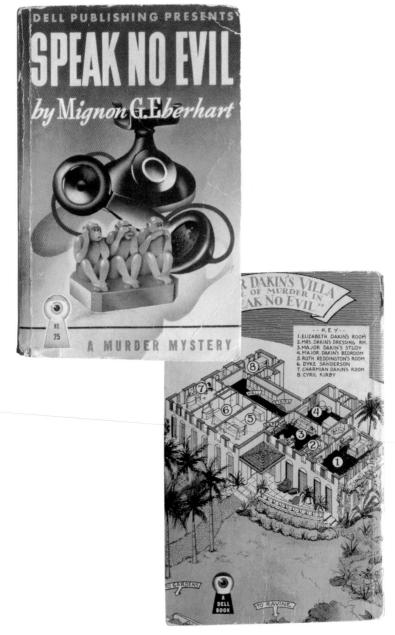

PREVIOUS SPREAD, FROM LEFT: Bantam Books, New York, 1946. Bantam Books, New York, 1946. Artist: Robert G. Harris. ABOVE: Dell Books, New York, 1943. Artists: Front Cover: Gerald Gregg, Back Cover: Ruth Belew. OPPOSITE: Dell Books, New York, 1948

A DELL BOOK

DELL
371

A lonely seaside... Lust to kill...

WISTERIA COTTAGE

Robert M. Coates

THE CASE OF THE
SUBSTITUTE FACE

ERLE STANLEY GARDNER

MANSO

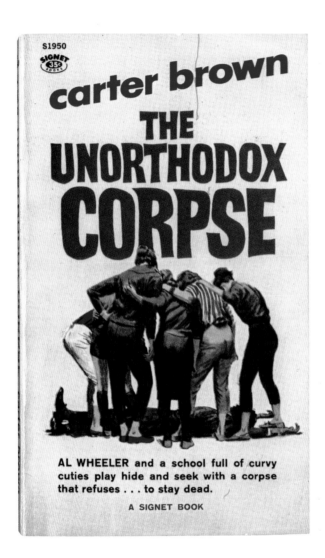

OPPOSITE: Pocket Books, New York, 1943. Artist: Leo Manso. ABOVE: Signet Books, New York, 1961. FOLLOWING SPREAD, FROM LEFT: Pocket Books, New York, 1961. Detail from *The Blonde Died Dancing*, Dell Books, New York, 1956

Perry Mason

the case
of
the
**gilded
lily**

ERLE STANLEY
GARDNER

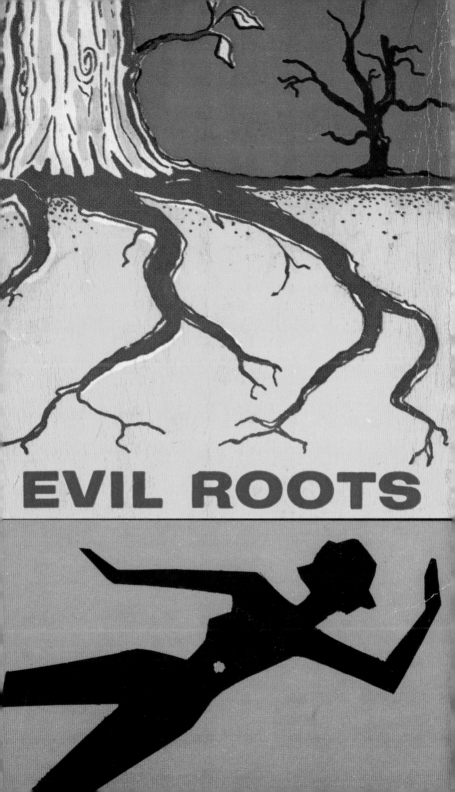

EVIL ROOTS

Love and Lust

The real boom in romance novels (and, by extension, their cover art, as exemplified by the "clinch") didn't get underway until the 1960s. The popularity of these "bodice rippers" has proved enduring, and their covers have even launched the career of models like Fabio. Over time, these covers have become extremely formulaic, but their antecedents belong to the early paperbacks. Scantily clad women, often in peril and caught up in the arms of (or in close proximity to) stalwart, virile men, soon became the norm. The realistic style of James Avati, which already graced most Signet novels, set the standard, and was quickly taken up by artists like Rudolph Belarski and Stanley Meltzoff. Romance remains the most popular form of fiction on the market today.

ABOVE: Signet Books, New York, 1955. OPPOSITE: Cardinal Editions, New York, 1960. FOLLOWING SPREAD: Popular Library, New York, 1956

35c

CARDINAL
EDITION

C·411

ERROL FLYNN

Showdown

A dashing,
turbulent novel of
passion and exotic
adventure in the South Seas
by the author of
MY WICKED, WICKED WAYS

THE
COMPLETE
BOOK

WHERE WOMEN ARE TABOO

"Hard-boiled approach and machine-gun dialogue. The central situation is dramatic ...A fast and readable book."
THE NATION

Guarding tough German prisoners was Sergeant Ben Hoffman's Army job after the war. And since women were taboo at the lonely Carolina camp, Ben and his soldier friends had almost as rough a time as their captives.

For their only diversions were on-the-base brawls and off-limits parties with WAC's. And even "nice" local girls like Anne could bring trouble to men who let themselves grow too restless ...

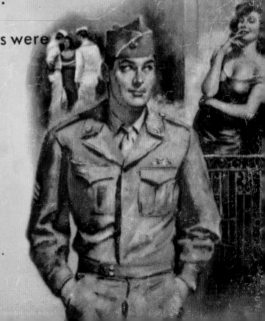

A Story Of Lonesome Soldiers And Bored Women 25c

EB64

The Battle Done

S. LEONARD RUBINSTEIN

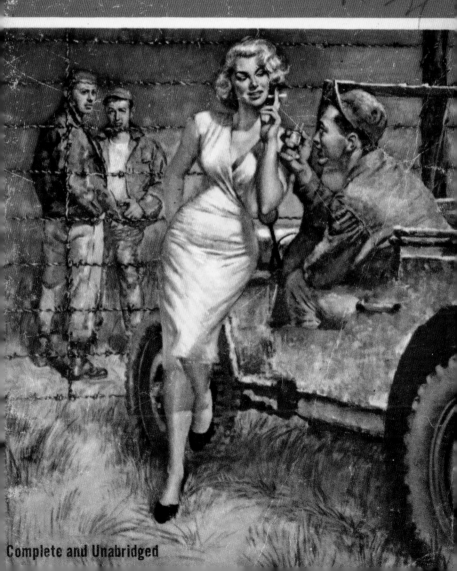

Complete and Unabridged

His Majesty's Highwayman

DONALD BARR CHIDSEY

His daring masquerade led him to a beautiful woman and a treacherous trap.

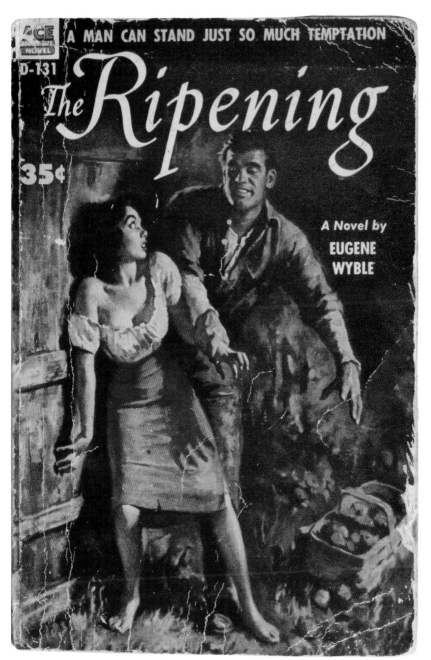

OPPOSITE: Perma Books, New York, 1959. Artist: Charles
ABOVE: Ace Books, New York, 1955

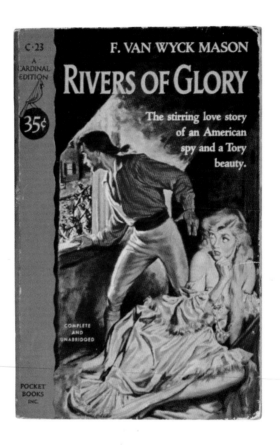

ABOVE: Cardinal Editions, New York, 1952. Artist: Ernest Chiriaka
OPPOSITE: Signet Books, New York, 1954. Artist: Stanley Zuckerberg

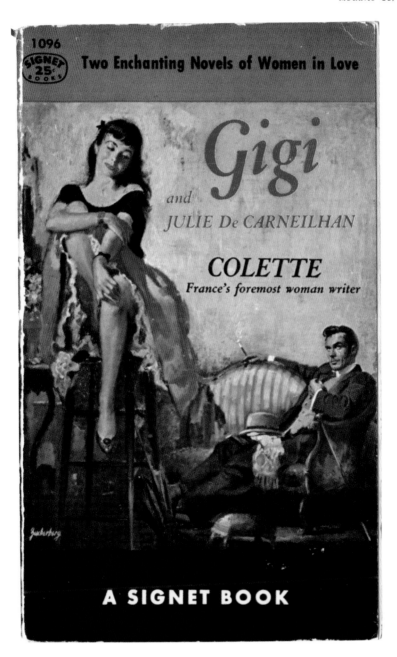

1096

SIGNET 25¢ BOOKS

Two Enchanting Novels of Women in Love

Gigi

and JULIE De CARNEILHAN

COLETTE

France's foremost woman writer

A SIGNET BOOK

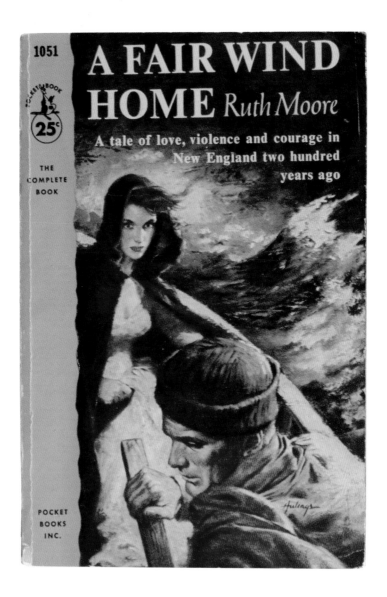

ABOVE: Pocket Books, New York, 1955. Artist: Clark Hulings
OPPOSITE: Pocket Books, New York, 1953. Artist: Tom Dunn

She wanted a strong man's love

Candlemas Bay

RUTH MOORE

A novel of Maine fishermen,
selected by The Literary Guild

A1540

A BANTAM GIANT 35¢

ROBERT WILDER

WRITTEN ON THE WIND

The story of a family torn by illicit passion and the scandal that blew the lid off!

NOT ONE WORD CUT

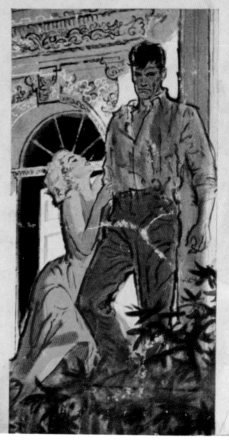

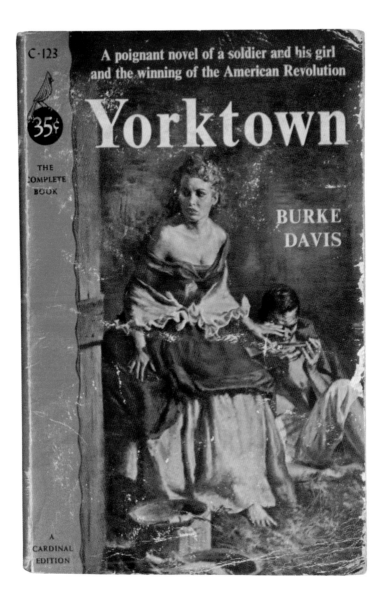

ABOVE: Bantam Books, New York, 1952. Artist: Charles. OPPOSITE:
Cardinal Editions, New York, 1954. Artist: Tom Dunn.
FOLLOWING SPREAD: Perma Books, New York, 1953, 1951, respectively

PERMA BOOKS

P226

DOUBLEDAY

THE BRUTALLY FRANK NOVEL
OF A DOCTOR WHO TOOK THE
EASY WAY TO SUCCESS

35¢

IN CANADA

SPENCER BRADE, M.D.

FRANK G
SLAUGHTER

author of
THE GOLDEN
ISL

COMPLETE AND UNABRIDGED

A GIRL CAN GROW UP IN A FEW HOURS
ASHORE IN THE TROPICS...

35¢

IN CANADA 39¢

One Tropical Night

(THE SHIP AND THE SHORE)

COMPLETE
AND
UNABRIDGED

PERMA BOOKS

P109

VICKI
BAUM

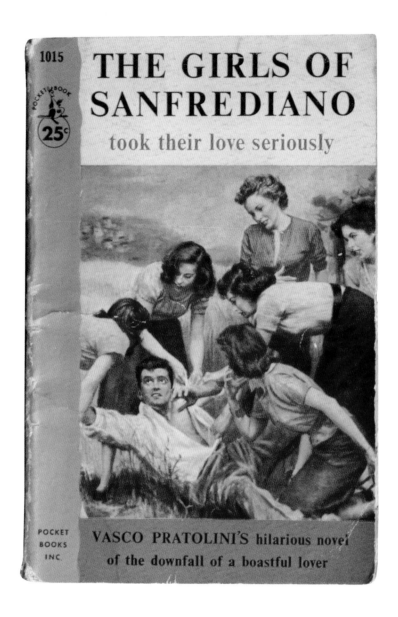

Pocket Books, New York, 1954. Artist: Tom Dunn

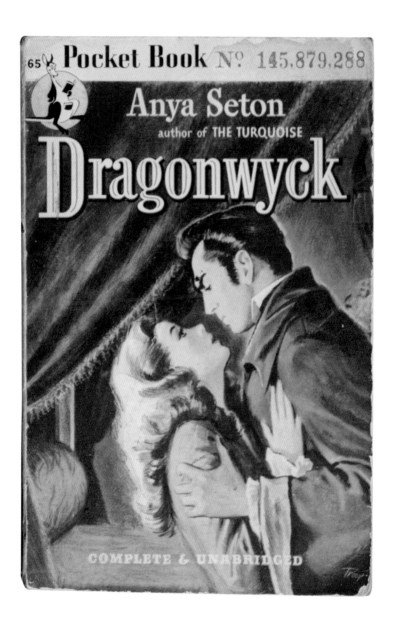

Pocket Books, New York, 1946. Artist: Troop

75¢

GIANT CARDINAL EDITION GC·784

THE COMPLETE BOOK

Where Love Has Gone

The sensational new novel by the author of THE CARPETBAGGERS

Harold Robbins

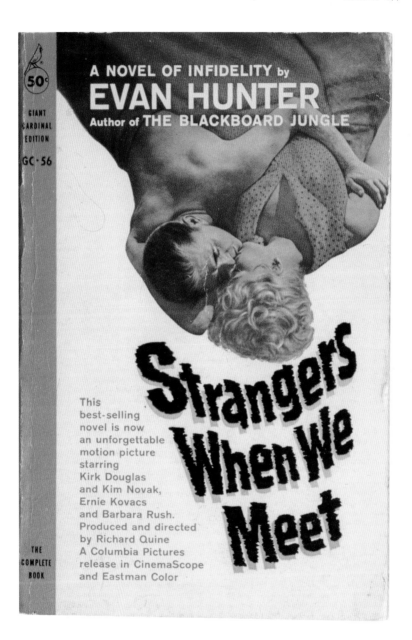

OPPOSITE AND ABOVE: Cardinal Editions, New York, 1963, 1959, respectively

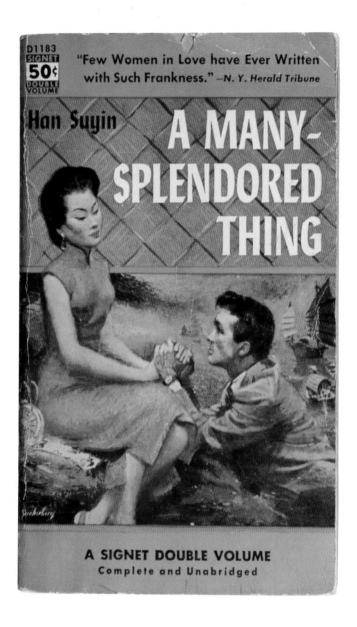

Signet Books, New York, 1955. Artist: Stanley Zuckerberg

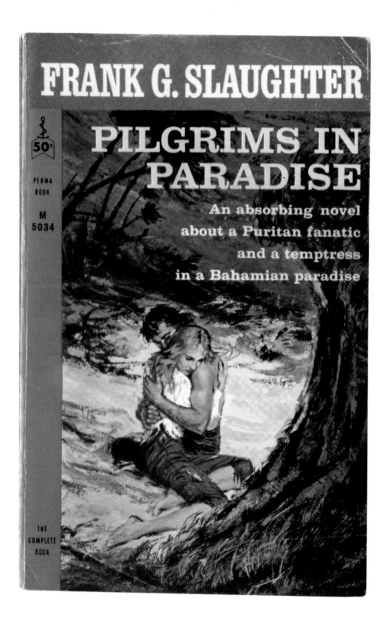

Perma Books, New York, 1961. FOLLOWING SPREAD: Dell Books,
New York, 1960. Artist: Robert K. Abbett

WOMEN WERE HIS SECOND GREAT LOVE

He was Count Cardinali, internation playboy, handsome, animal — with deadly charm no woman could resist.

When Barbara Lang met Cesare Cardin she was New York's top fashion model matchless machine — cold, imperson perfect. But like many women before he she was swept with a passion so strong consumed her, so intense it frighten her.

Half jokingly she called him her <u>angel death.</u>

Theirs was a torrid romance. They we seen everywhere together, Vegas, Mia New York. And strangely, a chain of v lence followed them as they traveled three murders, each carved by a dea knife, each disposing of a dangerous w ness against the all-powerful Mafia.

She was blinded by love, but could s close her eyes to what she saw—the kn that lashed out for the world's most cious crime syndicate, the knife that v held by her <u>angel of death.</u>

Cover painting by BOB ABI

Cover printed in U

ELL

RST
TION

84

50¢

HAROLD ROBBINS

author of
THE CARPETBAGGERS
and WHERE LOVE HAS GONE

Stiletto

DELL PUBLISHING PRESENT

THE *PHANTOM* OF THE OPERA

by Gaston Leroux

A DELL MURDER MYSTERY

The Dark Side

Surprisingly, this genre did not really take off till quite late. Other than the classics—*Dracula, Frankenstein, Dr. Jekyll and Mr. Hyde, The Phantom of the Opera*—most tales of ghosts and terror were marketed as a subset of the existing mystery category. It wasn't until the 1970s and the earliest works by Stephen King that horror paperbacks really sold in the millions of copies.

OPPOSITE: Dell Books, New York, 1955. BELOW: Detail from *Frankenstein*, Pyramid Books, New York, 1957

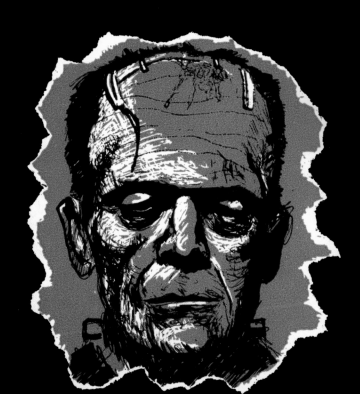

The ultimate in terrifying tales

THE MACABRE READER

Edited by Donald A. Wollheim

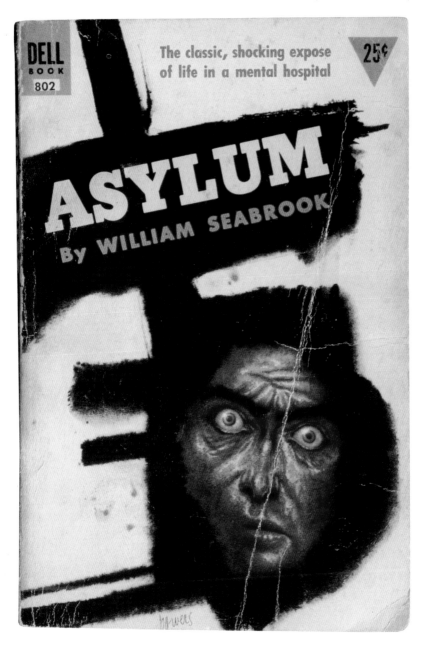

OPPOSITE: Ace Books, New York, 1959. ABOVE: Dell Books, New York, 1954. Artist: Bowers

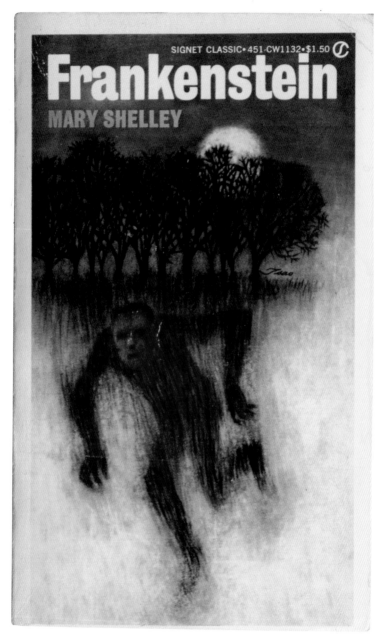

ABOVE: Signet Books, New York, 1965. OPPOSITE: Airmont Books, New York, 1963
FOLLOWING SPREAD, FROM LEFT: Belmont Books, New York, 1961.
Dell Books, New York, 1945. Artist: Victor Kalin

AIRMONT BOOKS 50c

MARY SHELLEY

Frankenstein

COMPLETE AND UNABRIDGED

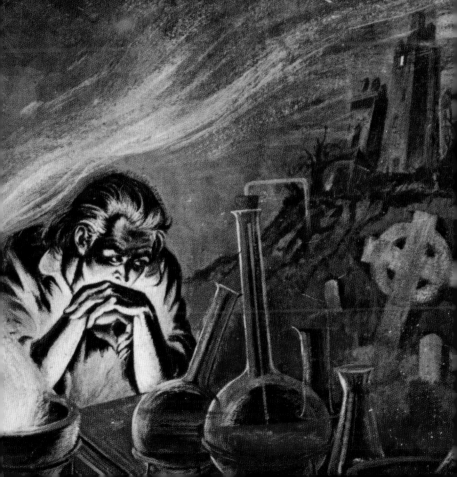

Dashiell Hammett

CREEPS BY NIGHT

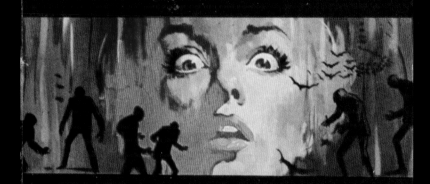

10 Great Weird Tales

by

WILLIAM FAULKNER
CONRAD AIKEN
STEPHEN VINCENT BENÉT
and other masters of the horror story

230 BB 35¢

ELL
183

35¢

She led a
double life—wife
to one man,
wanton to many!

NIGHTMARE

(METHINKS THE LADY)

GUY ENDORE

Author of
"King of Paris"

Other Worldly

While this genre had its beginnings with Jules Verne and H. G. Wells, among others, in the 19th century, its popularization began in force with pulps like *Amazing Stories* in 1926. Many of the pulp writers soon crossed over into paperbacks, including Donald A. Wollheim, Robert A. Heinlein, Arthur C. Clarke, and Frederik Pohl. Like their pulp brethren, these paperbacks sported some of the liveliest and most inventive cover illustrations in the history of popular fiction.

DOOMED

Crushing gravity—thin air—winters of unimaginable cold—searing summers under two suns—a deadly wasteland teeming with monsters and killing fever—

That was Ragnarok, the most dreaded planet yet discovered. And Ragnarok was where a thousand untrained Earthmen—and women and children—were brutally marooned by a sadistic enemy.

Two hundred died the first night.

In the morning, the survivors knew what they must live for—revenge!

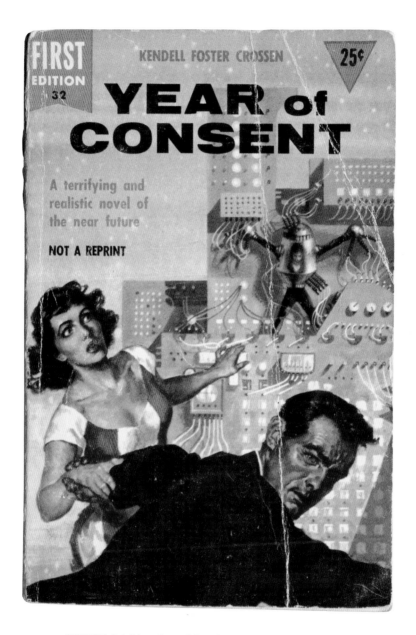

OPPOSITE: Detail from *Space Prison*, Pyramid Books, New York, 1958.
Artist: Ralph Brillhart. ABOVE: Dell Books, New York, 1954

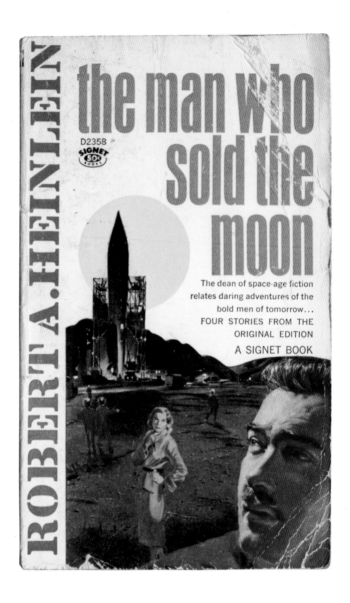

ABOVE: Signet Books, New York, 1951. OPPOSITE: Ace Books, New York, 1959

the HIDDEN PLANET

SCIENCE-FICTION ADVENTURES ON VENUS

by CHAD OLIVER • LEIGH BRACKETT
LESTER DEL REY • J. T. McINTOSH
STANLEY G. WEINBAUM

Edited by
Donald A. Wollheim

MEDALLION
F780
50¢

A TRACE OF MEMORY

KEITH LAUMER

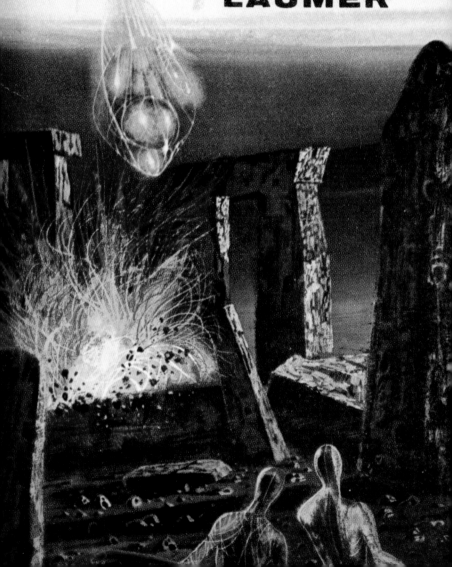

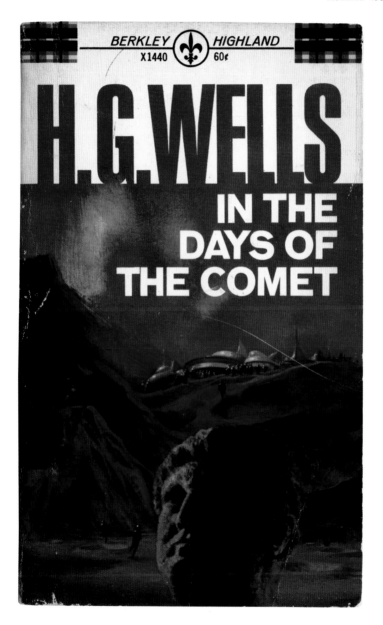

OPPOSITE: Berkley Books, New York, 1963. ABOVE: Berkley Books, New York, 1967

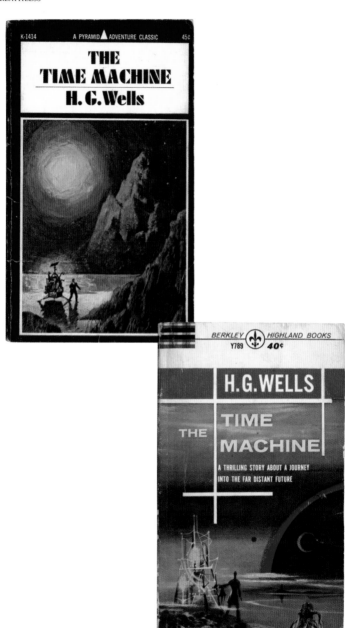

ABOVE: Pyramid Books, New York, 1966. Artist: Len Goldberg
BOTTOM: Berkely Books, New York

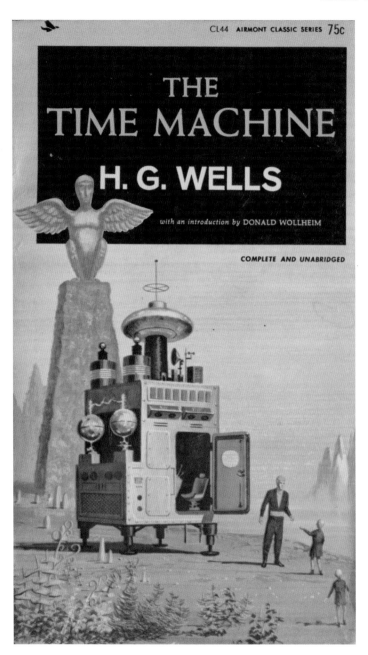

ABOVE: Airmont Books, New York, 1964. Artist: Stanley Zuckerberg. FOLLOWING SPREAD, FROM LEFT: Paperback Library. New York, 1965. Pyramid Books, New York, 1967

Commander Craig faces a hideous death as he attempts to save the world

Beyond The Black Enigma

BART SOMERS

X-1657 60¢

PYRAMID
SCIENCE FICTION

ONE AGAINST THE LEGION

An incredible web of terror shrouded
the Universe—the work of a phantom
that called itself God

JACK WILLIAMSON

PLUS
First publication anywhere of a
NEW LEGION OF SPACE novelette

AIRMONT 40c

A Science-Fiction tale of a community that had miraculously changed to metal.

INVADERS
FROM
RIGEL

FLETCHER PRATT

Airmont Books, New York, 1964

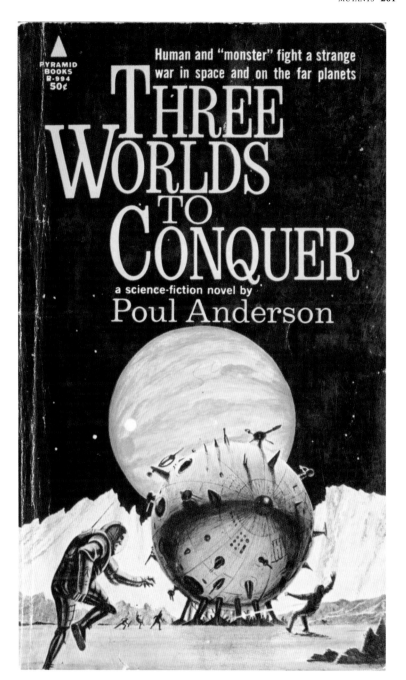

Pyramid Books, New York, 1964. Artist: Jack Gaughan

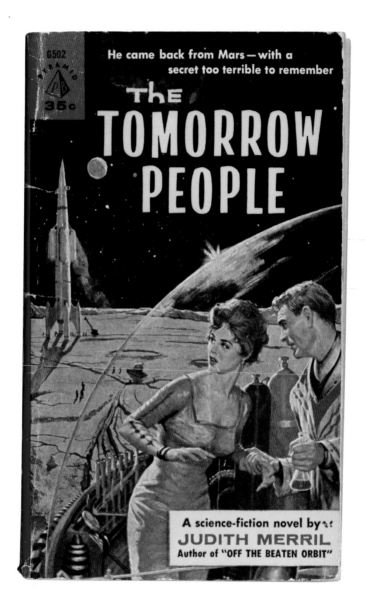

ABOVE: Pyramid Books, New York, 1960. Artist: Robert Schulz
OPPOSITE: Berkley Books, New York, 1950

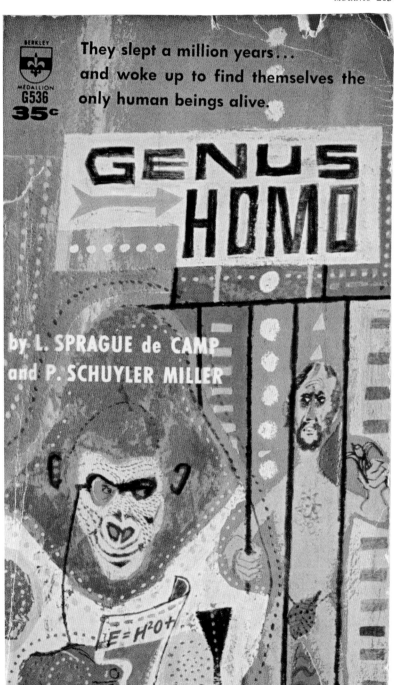

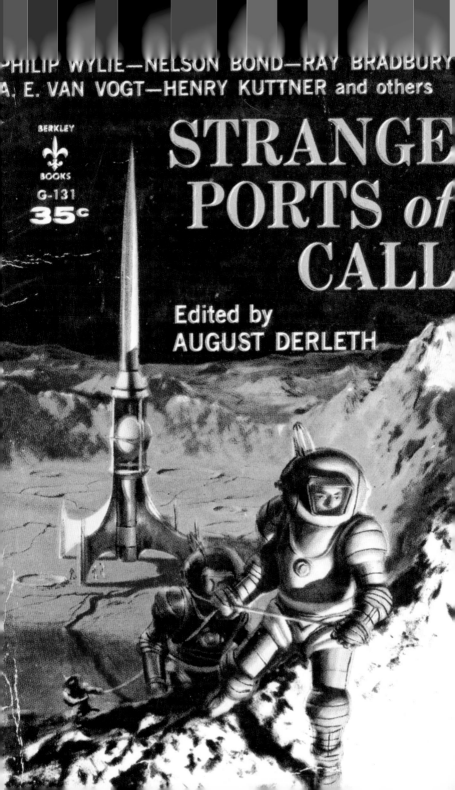

PHILIP WYLIE—NELSON BOND—RAY BRADBURY
A. E. VAN VOGT—HENRY KUTTNER and others

BERKLEY BOOKS

G-131

35c

STRANGE PORTS of CALL

Edited by
AUGUST DERLETH

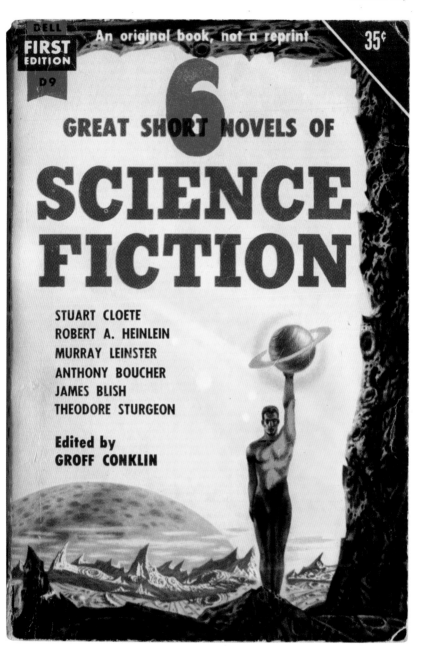

OPPOSITE: Berkley Books, New York, 1958. ABOVE: Dell Books,
New York, 1954. Artist: Richard Powers. FOLLOWING SPREAD, FROM LEFT:
Signet Books, New York, 1960. Popular Library, New York, 1944

S1840

Robert Sheckley

THE
STUNNING
NOVEL OF
A FUTURE
EARTH— WHEN
ONE VAST
AND STRATIFIED
SOCIETY THREATENS
ALL WHO FAIL
TO CONFORM

THE STATUS CIVILIZATION

A Novel of Tomorrow

A SIGNET BOOK

60-2445

60c

THE TENTH PLANET

WHEN CAPTAIN FUTURE DISAPPEARS, AND AN IMPOSTOR TAKES OVER, THE SOLAR SYSTEM FACES FINAL DOOM...

BY BRETT STERLING

ABOVE: Lancer Books, New York, 1962. OPPOSITE: Tempo Books, New York, 1962

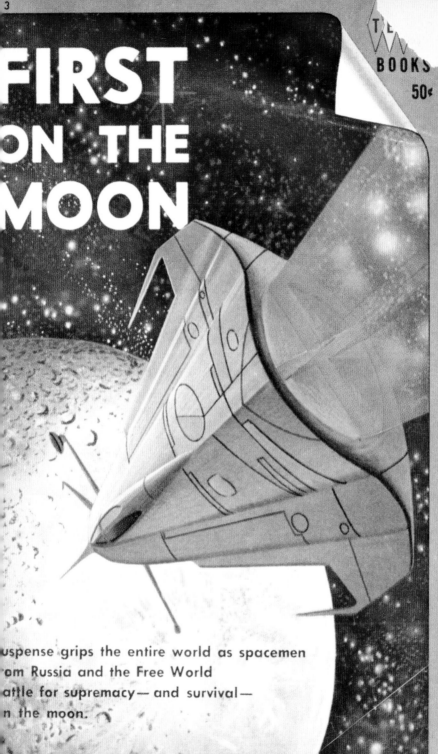

FIRST ON THE MOON

BOOKS

50¢

suspense grips the entire world as spacemen
from Russia and the Free World
battle for supremacy— and survival—
on the moon.

By Hugh Walters

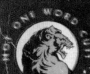
NOT ONE WORD CUT!

ONE WOMAN LEADS A WAR BETWEEN THE SEXES
A Fantastic Novel of Science-Fiction

the HAPLOIDS

25¢

JER
SO

LION
118

OPPOSITE: Lion Books, New York, 1953. ABOVE: Signet Books, New York, 1951

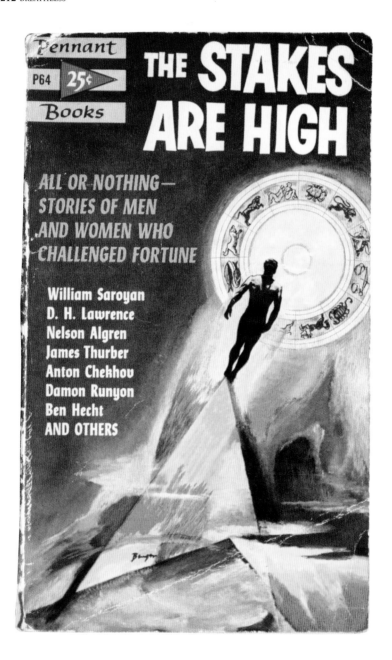

ABOVE: Pennant Books, New York, 1954. OPPOSITE: Paperback Library, New York, 1966

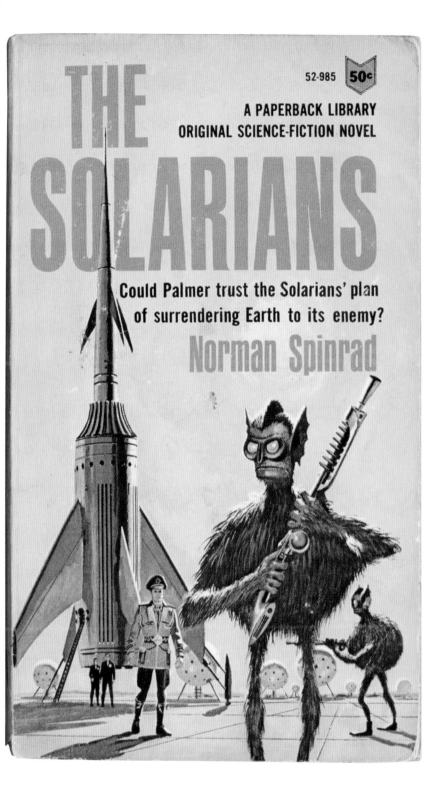

52-985 50¢

A PAPERBACK LIBRARY
ORIGINAL SCIENCE-FICTION NOVEL

THE SOLARIANS

Could Palmer trust the Solarians' plan
of surrendering Earth to its enemy?

Norman Spinrad

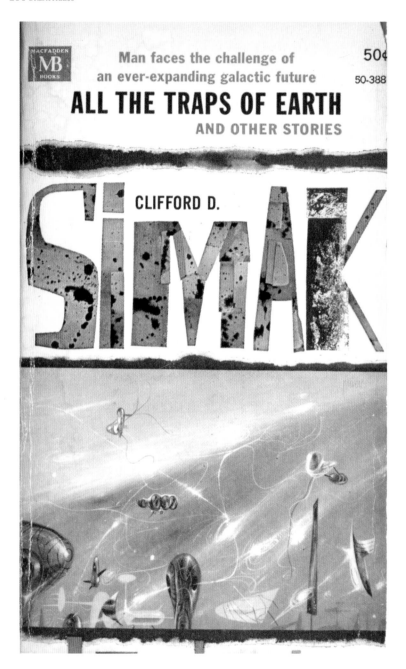

ABOVE: Macfadden Books, New York, 1963
OPPOSITE: Berkley Books, New York, 1953

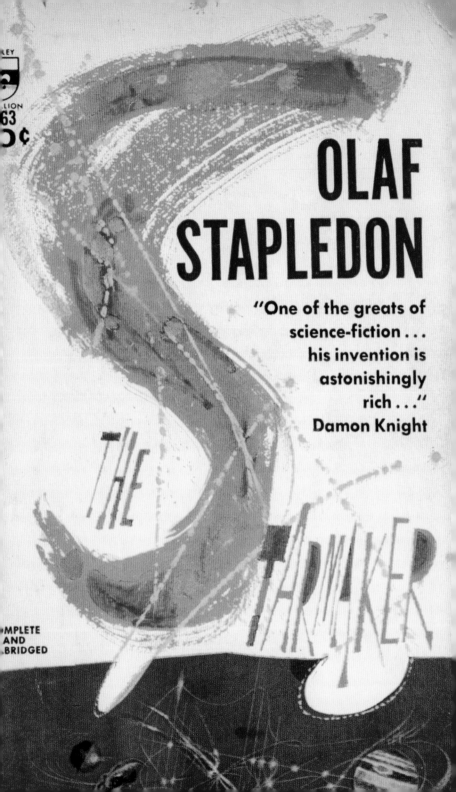

BERKLEY

MEDALLION

G-63

50¢

OLAF STAPLEDON

"One of the greats of science-fiction . . . his invention is astonishingly rich . . ."
Damon Knight

THE STARMAKER

COMPLETE AND UNABRIDGED

M57

3.

"The book you must read
if you want to know what Communism is."

LENIN

SPECIAL ABRIDGED
EDITION

DAVID
SHUB

A fascinating biography of the man who, from
his grave, directs the strategy of the Kremlin today.

Nothing But The Truth

The premier artist of the nonfiction paperback at Signet was Robert Jonas. The American-born Jonas studied art at New York University and met Dutch painter Willem de Kooning there. As a result of their friendship, he was introduced to many members of the art world's avant-garde, who would soon gain fame as part of the Abstract Expressionist movement.

Jonas was heavily influenced by European poster artists such as Jean Carlu, A.M. Cassandre, and the American-born former expatriate E. McKnight Kauffer. "An enormous amount of European intellect flooded the United States between 1934 and 1939, all people fleeing the Nazis," he recalled. "They created a new intellectual climate in America and I was lucky enough to be part of it. . . . I didn't like the idea of American art; I was only interested in international art." This European influence was felt throughout the industry: German designer Lucien Bernhard created the first American Penguin format, while his compatriot Jan Tschichold refined the Penguin trademark, and Elaine de Kooning—Willem's wife—designed the company's flying-pelican colophon.

At first, Jonas's work graced both fiction and nonfiction covers, particularly for Signet, and he became closely identified with author James T. Farrell. However, with James Avati's arrival on the scene, Jonas's graphic technique was soon replaced by the more realistic painterly style. Jonas tried to keep up, painting in a realist manner under the nom de plume "Rob-Jon"—sadly, with little success. His work remained well suited to nonfiction, however. Philosophically, Jonas embraced the paperback's egalitarian promise. "I've never believed in elitist art," he once said; "I believe in art for the people."

OPPOSITE, FOLLOWING SPREAD AND PAGE 220: Mentor Books, New York, 1950, 1953, 1949. PAGE 221: Penguin Books, New York, 1946. Artist: Robert Jonas

M81

AARON COPLAND'S

35c
IN CANADA 50c

Popular Guide to Greater Musical Enjoyment

WHAT TO LISTEN FOR IN
MUSIC

A Mentor Book

A Study of Greatness

BEETHOVEN

HIS SPIRITUAL DEVELOPMENT

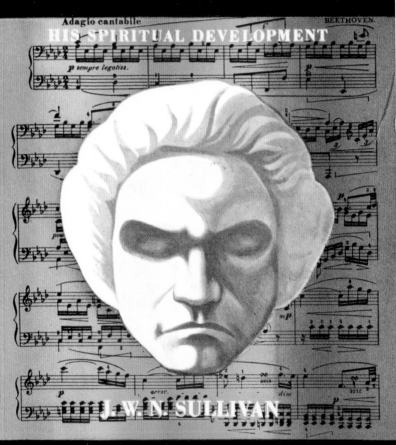

J. W. N. SULLIVAN

Mentor Books

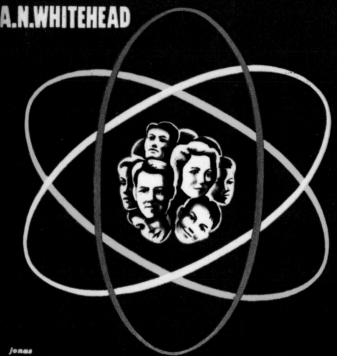

"The most significant restatement . . . of the present relations of science, philosophy, and life . . ." –John Dewey

M28

35¢
IN CANADA 50¢

SCIENCE AND THE MODERN WORLD

A.N. WHITEHEAD

A Mentor Book

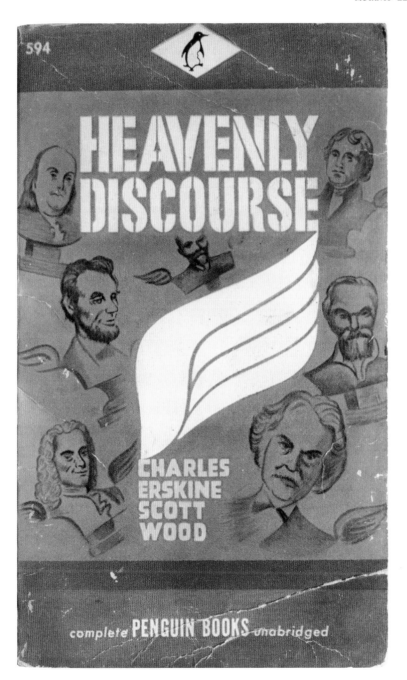

594

HEAVENLY DISCOURSE

CHARLES
ERSKINE
SCOTT
WOOD

complete **PENGUIN BOOKS** unabridged

MP434
60c

EXCELSIOR!

The True Believer

From the ultra-conservative right to the radical left, here is the noted analysis of one of the most frightening phenomena of modern times: the fanatic, the man who feels driven to join, and make others join, any extremist cause that gives meaning to his guilt-ridden existence.

ERIC HOFFER

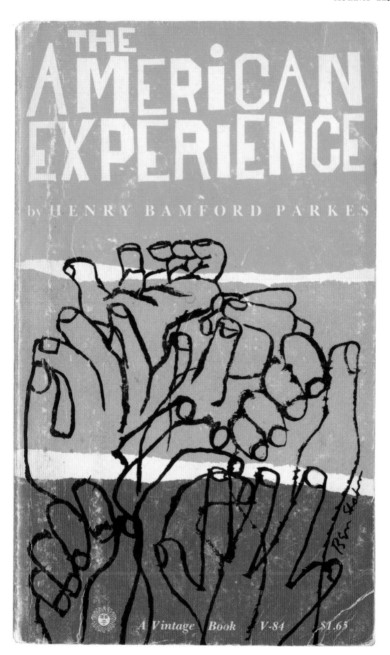

OPPOSITE: Mentor Books, New York, 1951
ABOVE: Vintage Books, New York, 1959. Artist: Ben Shahn

CROSSROADS OF THE WORLD

The Story of Times Square

by WILLIAM LAAS

POPULAR LIBRARY

PC105

75c

OPPOSITE: Popular Library, New York, 1965. ABOVE: Berkley Books, New York, 1959

The World of Nature in Action

Ks-333
35¢

JOHN H. STORER

The WEB of LIFE

BACTERIA • INSECTS • PLANTS • BIRDS • MAMMALS
Their relationship to each other and to their environment

A SIGNET KEY BOOK

ABOVE: Signet Books, New York, 1956. OPPOSITE: Signet Books, New York, 1960

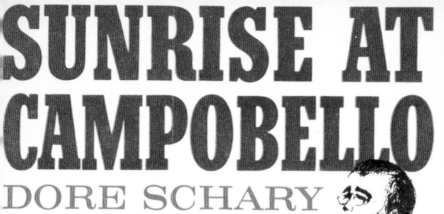

SUNRISE AT CAMPOBELLO

DORE SCHARY

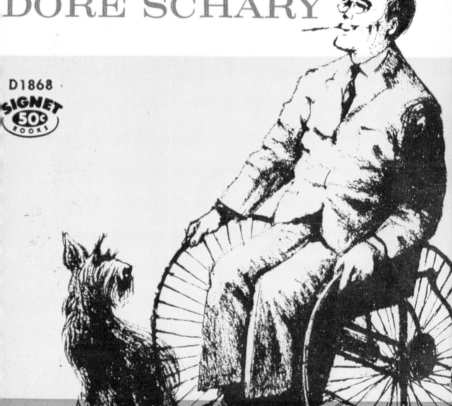

D1868

SIGNET 50¢ BOOKS

The intimate, courageous story of Franklin Delano Roosevelt's triumph over adversity, movingly dramatized by a gifted writer.

With eight pages of scenes from the Dore Schary Production for Warner Bros. release starring Ralph Bellamy and Greer Garson, and co-starring Hume Cronyn and Jean Hagen. Technicolor®.

A SIGNET BOOK COMPLETE AND UNABRIDGED

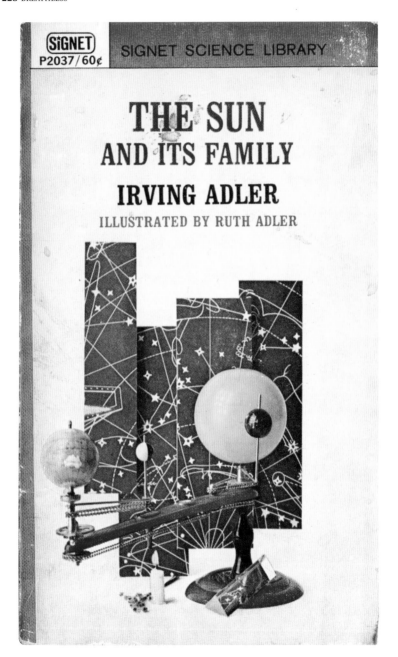

Signet Books, New York, 1962. Artist: Robert Jonas

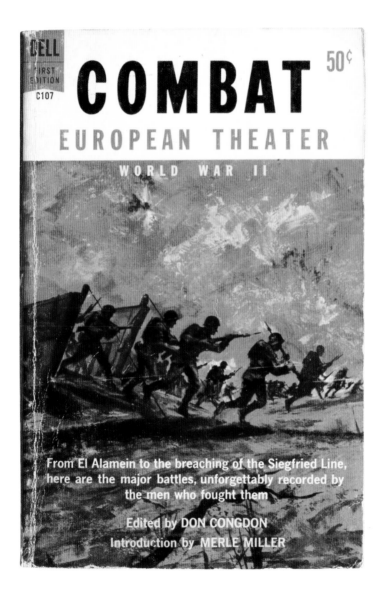

DELL
FIRST EDITION
C107

COMBAT
50¢
EUROPEAN THEATER
WORLD WAR II

From El Alamein to the breaching of the Siegfried Line, here are the major battles, unforgettably recorded by the men who fought them

Edited by DON CONGDON
Introduction by MERLE MILLER

Dell Books, New York, 1958

THOR HEYERDAHL
Author of KON-TIKI

GC·758

A CARDINAL GIANT · THE COMPLETE BOOK

AKU-AKU

The amazing story of a scientific expedition that uncovered **THE SECRET OF EASTER ISLAND**

WITH 32 PAGES OF FULL-COLOR PHOTOGRAPHS

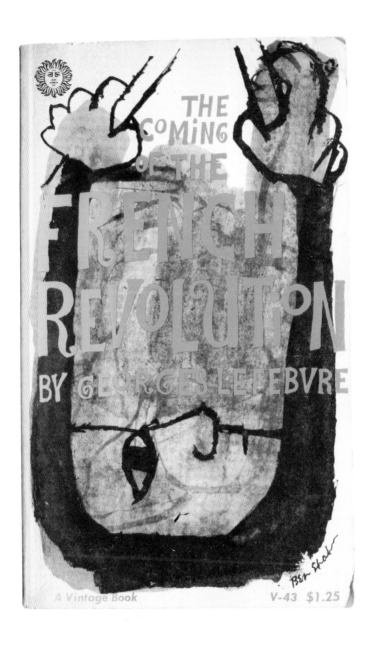

OPPOSITE: Cardinal Editions, New York, 1960. ABOVE: Vintage Books, New York, 1957. Artist: Ben Shahn. FOLLOWING SPREAD, FROM LEFT: Signet Books, New York, 1957. Mentor Books, New York, 1952

KO351
50c

The story of electricity in action

Electronics
FOR EVERYONE

Revised & up-to-date edition

TV
COLOR TV
RADIO, HI-FI
RADAR
● What They Are
● How They Work

Monroe Upton

A SIGNET KEY BOOK

MT717
75c

the creative process

Edited by BREWSTER GHISELIN

Explained in their own words by thirty-eight brilliant men and women including:
Albert Einstein • Vincent Van Gogh • Yasuo Kuniyoshi • Friedrich Nietzsche
Carl Gustav Jung • Mary Wigman • A. E. Housman • W. B. Yeats • Henry James
Henry Moore • Thomas Wolfe • D. H. Lawrence • and others

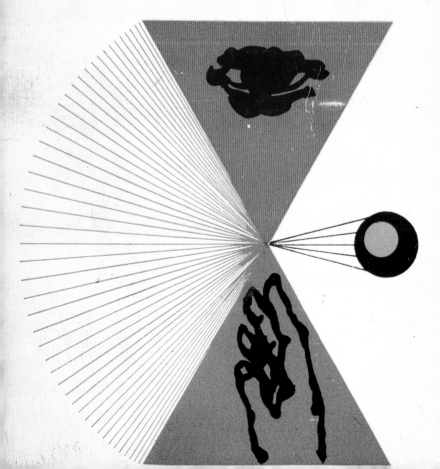

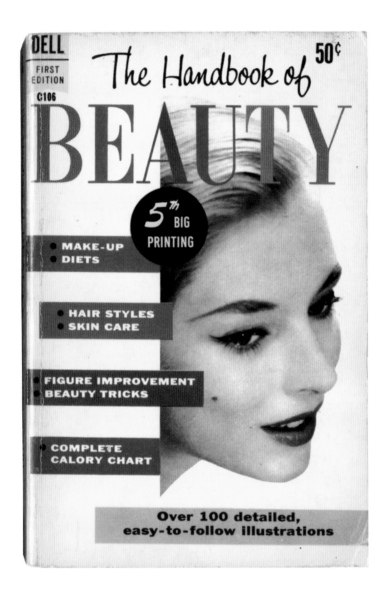

Dell Books, New York, 1955. Photo: William Stone

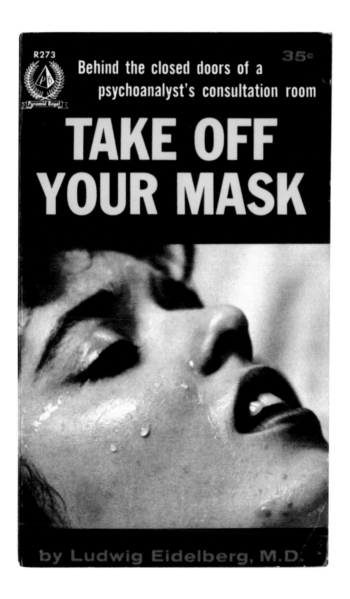

Pyramid Books, New York, 1957. Photo: Hugh Bell

25¢

"Authoritative and readable"
MINNESOTA DEPT. OF EDUCATION

SIGMUND FREUD FOR EVERYBODY

(SIGMUND FREUD)

RACHEL BAKER

Complete and
Unabridged

"Interesting interpretation of Freudian theories on sex, dreams, the ego and id, and some analysis of Freud's influence on art, literature and education." AMERICAN LIBRARY ASSOCIATION

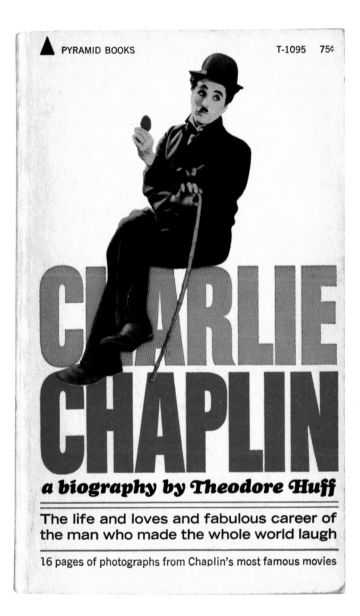

PYRAMID BOOKS T-1095 75¢

CHARLIE CHAPLIN

a biography by Theodore Huff

The life and loves and fabulous career of
the man who made the whole world laugh

16 pages of photographs from Chaplin's most famous movies

OPPOSITE: Popular Library, New York, 1955. ABOVE: Pyramid Books, New York, 1964

The Bard and Beyond

Poems, plays, and serialized novels all lent themselves well to the convenient size of the paperback, and enduring works by Homer, Sappho, Shakespeare, Cervantes, Dumas, and Dickens now found a home in the unlikeliest of places. Featuring more subdued covers than their contemporaries, these paperback editions of the classics were a boon to schoolchildren everywhere. Avon in particular made explicit the relationship between the world of literature and the mass-market paperback by their choice of name and colophon, featuring a likeness of the Bard himself.

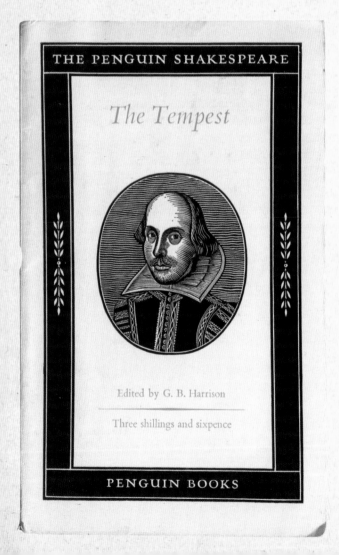

THIS PAGE: Penguin Books, Great Britain, 1937. Engraving by Reynolds Stone. OPPOSITE: Mentor Books, New York, 1956

STORIES FROM
Shakespeare

THE COMPLETE PLAYS OF
William Shakespeare

RETOLD BY **Marchette Chute**
Author of SHAKESPEARE OF LONDON

A MENTOR BOOK

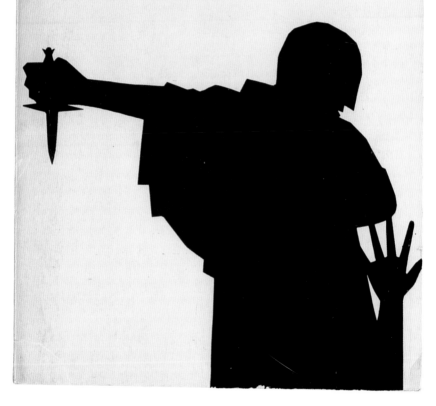

DELL
4326
35¢

THE LAUREL SHAKESPEARE

Julius Caesar

Francis Fergusson, General Editor
With a Modern Commentary by
PHILIP LAWRENCE

ABOVE AND OPPOSITE: Dell Books, New York, 1958, 1959, Design: Jerome Kuhl

DELL
3584
35¢

THE LAUREL SHAKESPEARE

Henry IV
Part One

Francis Fergusson, General Editor
With a Modern Commentary by
SIR RALPH RICHARDSON

Dutton Books, New York. Cover Design: Milton Glaser

Mentor Books, New York. Artist: Milton Glaser

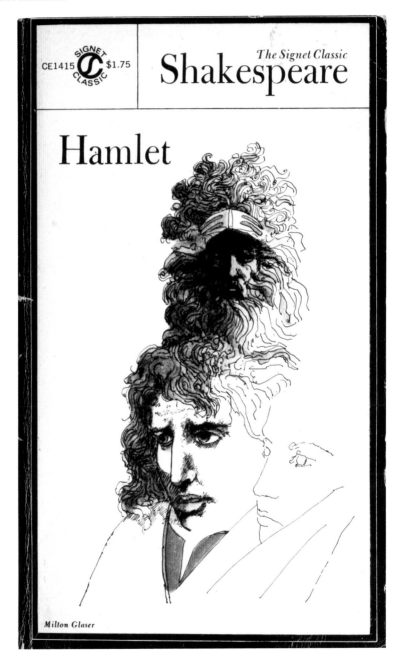

ABOVE AND OPPOSITE: Signet Books, New York, 1963. Artist: Milton Glaser

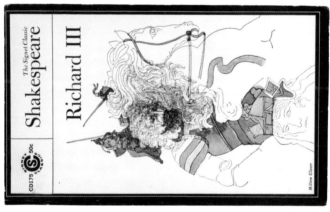

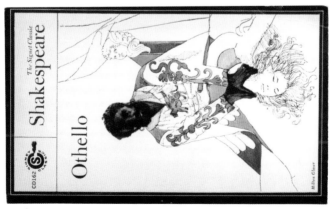

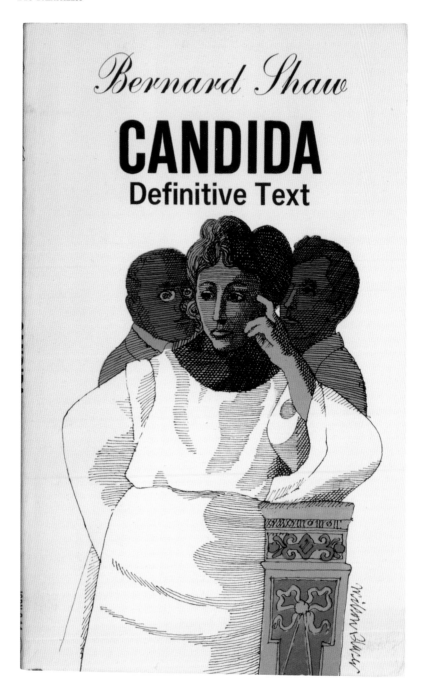

ABOVE AND OPPOSITE: Penguin Books, Baltimore, 1960. Artist: Milton Glaser

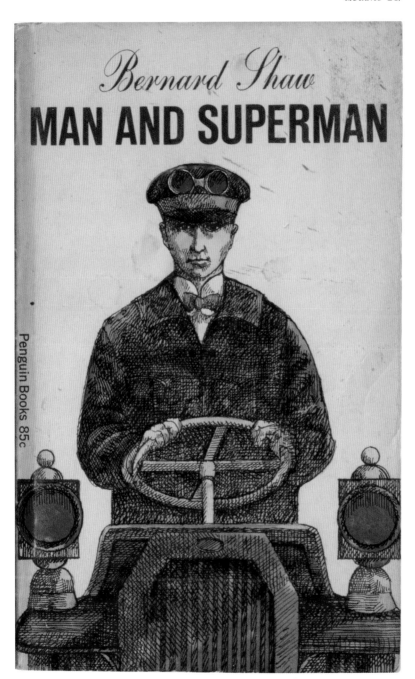

Bernard Shaw

MAN AND SUPERMAN

Penguin Books 85c

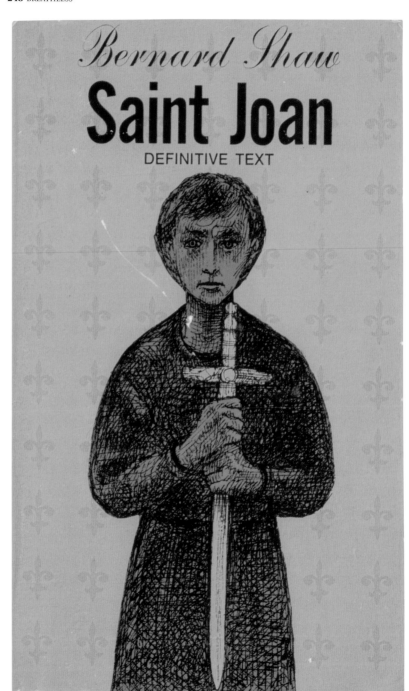

Bernard Shaw
Saint Joan
DEFINITIVE TEXT

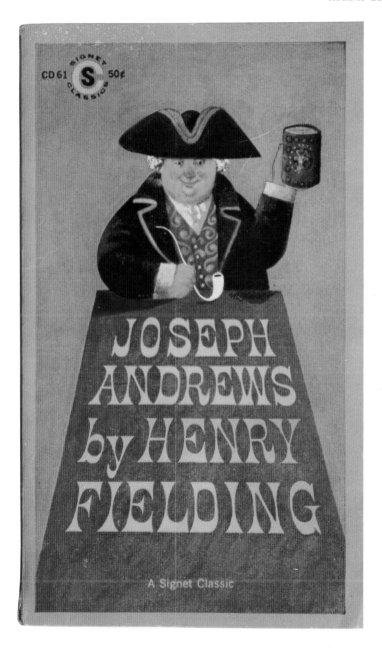

OPPOSITE: Penguin Books, Baltimore, 1960. ABOVE: Signet Books
New York, 1960. FOLLOWING SPREAD, FROM LEFT: Signet Books
New York, 1959, 1961. Artist: Milton Glaser

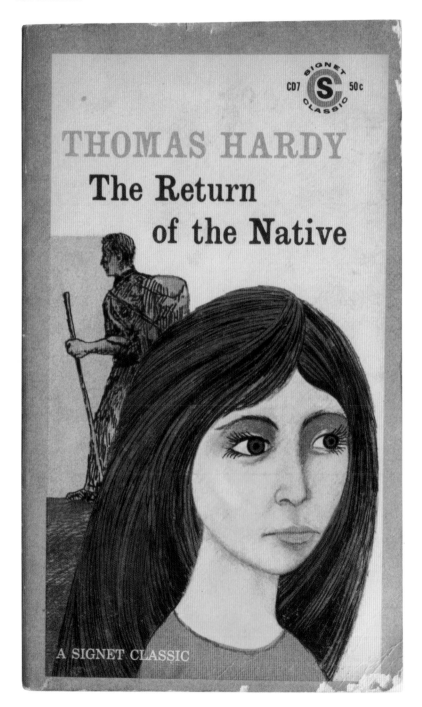

CD7 50c

SIGNET CLASSIC

THOMAS HARDY
The Return
of the Native

A SIGNET CLASSIC

A SIGNET CLASSIC•451-CJ1335•$1.95

Charles Dickens

Hard Times

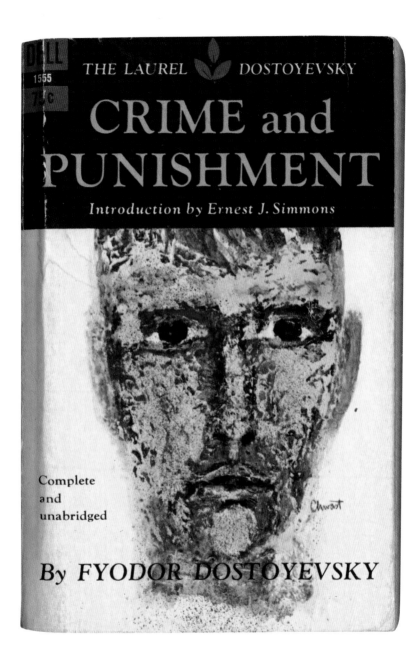

DELL
1555
75c

THE LAUREL DOSTOYEVSKY

CRIME and PUNISHMENT

Introduction by Ernest J. Simmons

Complete and unabridged

By FYODOR DOSTOYEVSKY

OPPOSITE: Dell Books, New York, 1959. Artist: Seymour Chwast
ABOVE: Signet Books, New York, 1962. Artist: Milton Glaser

Mentor Books, New York, 1950. Artist: Robert Jonas

Anchor Books, New York, 1952. Artist: Edward Gorey

ABOVE AND OPPOSITE: Airmont Books, New York, 1965, 1963

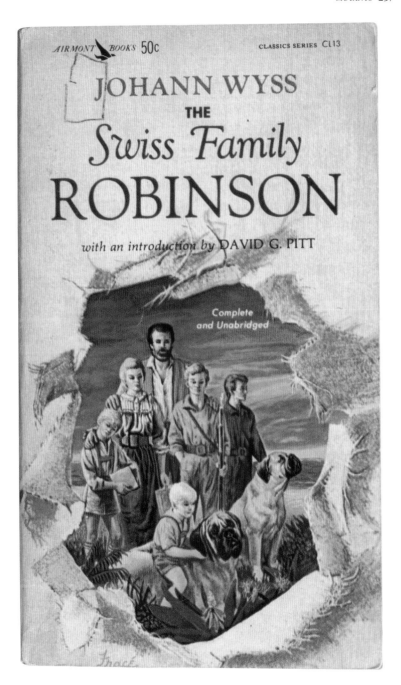

THE PELICAN
SHAKESPEARE
Henry IV Part Two
Edited by Allan G. Chester

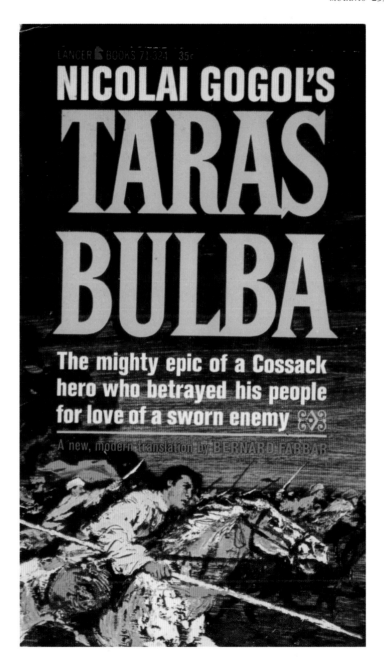

LANCER BOOKS 71-324 35¢

NICOLAI GOGOL'S

TARAS BULBA

The mighty epic of a Cossack hero who betrayed his people for love of a sworn enemy

A new, modern translation by BERNARD FARBAR

OPPOSITE: Penguin Books, New York, 1970. Artist: Milton Glaser, Design: Peter Rozycki
ABOVE: Lancer Books, New York, 1962

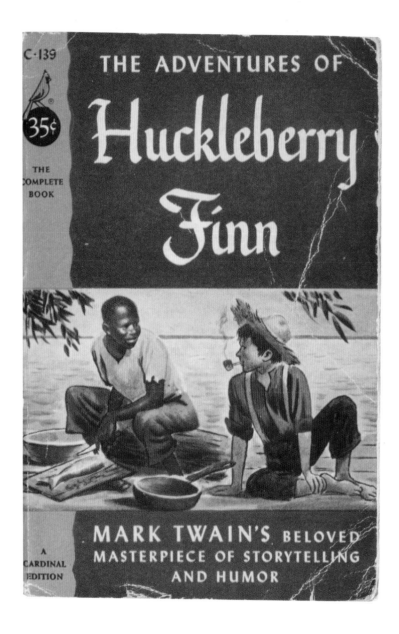

ABOVE: Cardinal Editions, New York, 1950. Artist: Harold Milton
OPPOSITE: Signet Books, New York, 1959

CD 2 50¢

MARK TWAIN
THE ADVENTURES OF TOM SAWYER

A SIGNET CLASSIC

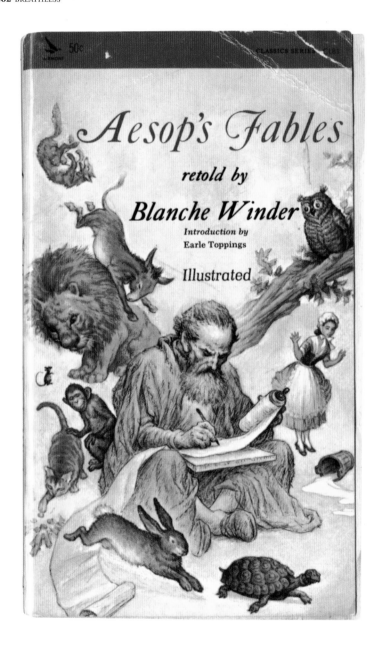

ABOVE AND OPPOSITE: Airmont Books, New York, 1965, 1964

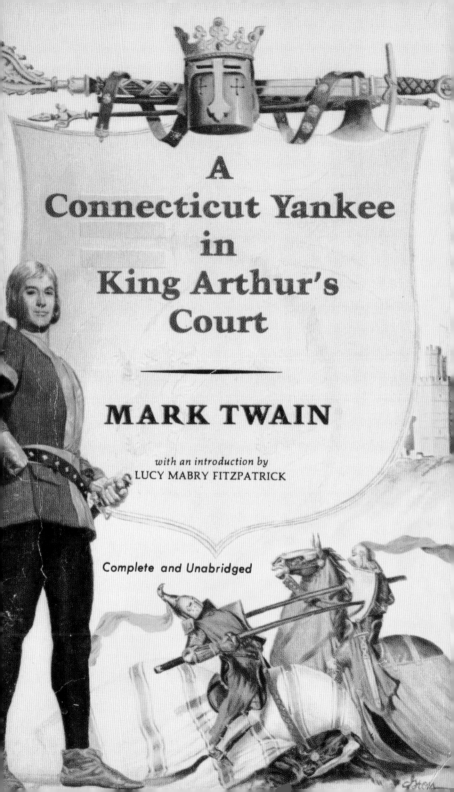

A Connecticut Yankee in King Arthur's Court

MARK TWAIN

with an introduction by
LUCY MABRY FITZPATRICK

Complete and Unabridged

A MENTOR BOOK 451·ME1911·$2.50

Eight Great Tragedies

Chwast

The complete texts
of the world's
great tragedies
from ancient times
to the present

AESCHYLUS
Prometheus Bound
SOPHOCLES
Oedipus the King
EURIPIDES
Hippolytus
SHAKESPEARE
King Lear
IBSEN
Ghosts
STRINDBERG
Miss Julie
YEATS
On Baile's Strand
O'NEILL
Desire Under the Elms

Edited by
Sylvan Barnet,
Morton Berman
and William Burto
Essays by
Aristotle, Hume,
Emerson, Tillyard,
Richards and Krutch

OPPOSITE: Mentor Books, New York, 1957. Artist: Seymour Chwast
ABOVE: Signet Books, New York, 1964. Artist: Milton Glaser

Lights, Camera, Tie-In

Movie tie-ins—as a genre, a true paperback original—featured some of the earliest photographic covers. The very first tie-ins were dust jackets wrapped around a particular book to announce the film version. The first of these appeared in 1948, for the novel *Chicken Every Sunday*, and featured a photograph of Celeste Holm and Dan Dailey. Soon these books were simply reissued with printed covers that utilized publicity stills from the films or paintings with the actors' likeness.

Pocket Books, New York, 1947. Artist: Troop

Erskine Caldwell

S581
SIGNET
35¢
BOOKS

GOD'S LITTLE ACRE

The world's most popular novel . . . illustrated
with scenes from the great
motion picture starring Robert Ryan,
Aldo Ray, Tina Louise and Buddy Hackett.
A Security Pictures Production
released thru United Artists.

A SIGNET BOOK Complete and Unabridged

Signet Books, New York, 1958

Signet Books, New York, 1958

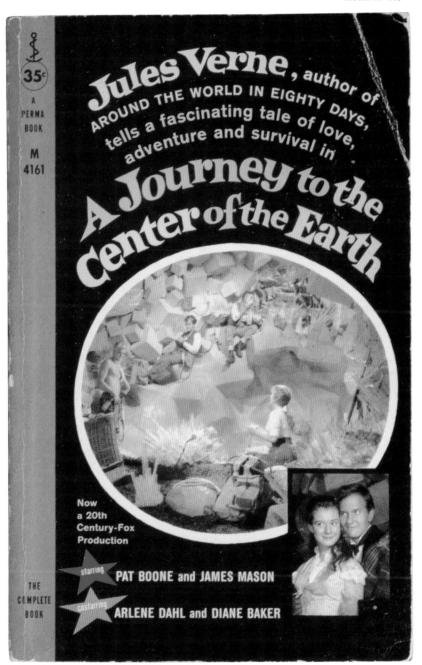

Perma Books, New York, 1959. Cover Design: Leon Gregori

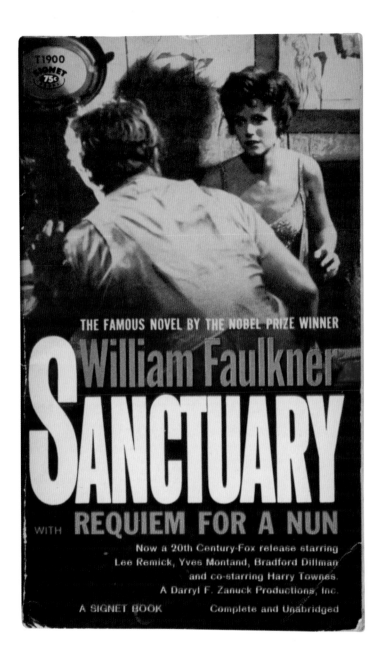

Signet Books, New York, 1954

Signet Books, New York, 1957. FOLLOWING SPREAD: Crest Books, New York, 1960

PSYCHO

An Alfred Hitchcock Production

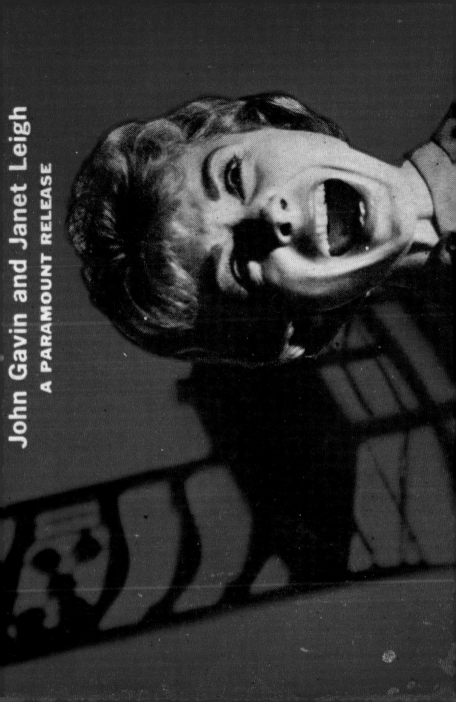

John Gavin and Janet Leigh
A PARAMOUNT RELEASE

Cover printed in U.S.A.

Dell Books, New York, 1960

SINNER!
ELMER GANTRY
WANTS YOU

TO SAVE YOUR SOU
TO SEE THE LIGH
HE WANTS YC
TO KNOW A
ABOUT HEAVEN
BUT NOT ABOU
HIS WHISK
AND HIS WOME

"The greatest, most v
and most penetrating s
of hypocrisy that has b
written since Voltai
—LITERARY REV

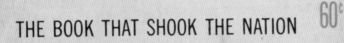

THE BOOK THAT SHOOK THE NATION 60¢

LMER GANTRY

BY NOBEL
PRIZE WINNER
SINCLAIR
LEWIS

Complete and
unabridged

OW DARINGLY BROUGHT TO THE SCREEN

Funny Bone

Usually an overlooked category, humor books at first consisted of collections of previously published material, such as the work of *New Yorker* cartoonist Charles Addams and, in the 1950s, selections from *Mad* magazine. Eventually, this genre grew to include original works published for the first time in paperback.

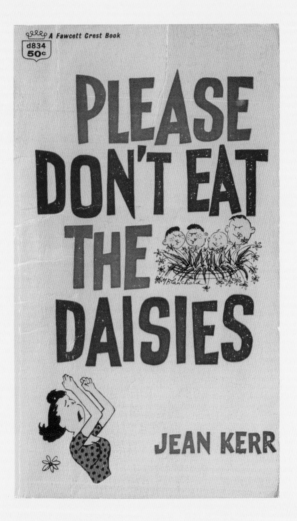

ABOVE: Fawcett Crest Books, New York, 1957. Artist: Martha Blanchard
OPPOSITE: Pocket Books, New York, 1945

the **POCKET BOOK of**

JOKES

edited by BENNETT A. CERF

author of 'Try and Stop Me'

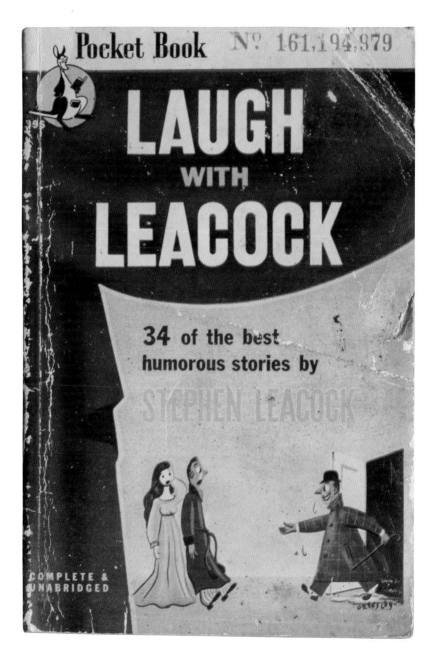

Pocket Books, New York, 1947

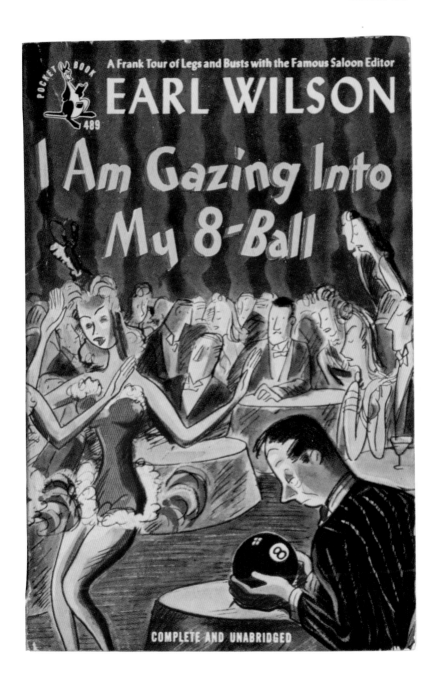

Pocket Books, New York, 1948. Artist: John Groth

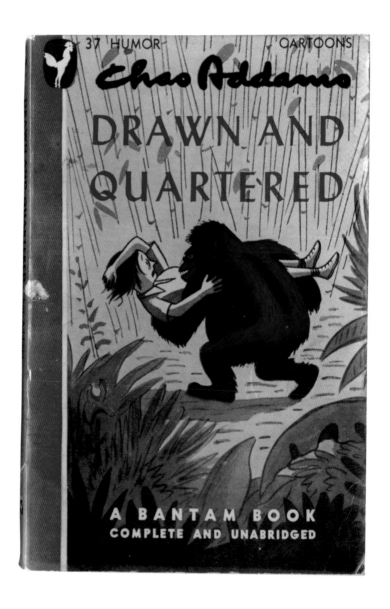

Bantam Books, New York, 1946

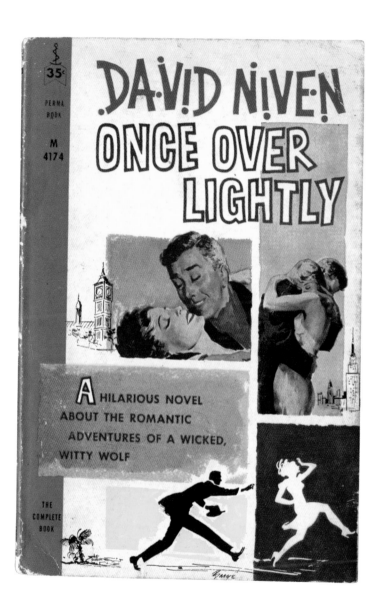

Perma Books, New York, 1960

Lavender Liaisons

Originally designed to appeal to the prurient interest of male readers, this genre unto itself soon found an unintended audience: gay women. The success of the category was immediate. *Women's Barracks* by Tereska Torres, published by Gold Medal in 1950, sold an astounding 1,640,000 copies in the first four years over eight editions, a fact that the publisher proudly displayed across the original cover art. Congress cited this book as obscene during a hearing of the Select Committee on Current Pornographic Materials in 1954. The genre proved so successful that male authors like Michael Avallone, Lawrence Block, R. V. Cassill, Fletcher Flora, Robert Silverberg, and Donald E. Westlake jumped on the bandwagon, often employing feminine-sounding noms de plume.

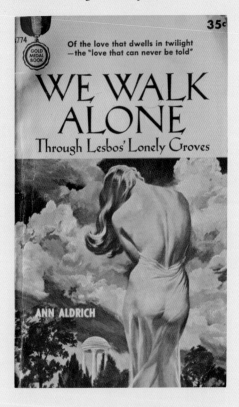

ABOVE: Gold Medal Books, New York, 1955
OPPOSITE: Gold Medal Books, New York, 1950

379

GOLD MEDAL BOOK

THE FRANK AUTOBIOGRAPHY
OF A FRENCH GIRL SOLDIER

Women's Barracks

TERESKA TORRES

AVIS!

FRANCE

EIGHTH PRINTING
1,640,000 COPIES SOLD

THE
ATOMIC AGE
OPENS

Changing World

The intimacy and immediacy of the paperback were also perfect for comment on pressing social concerns. The bomb, the Cold War, the civil-rights movement, juvenile delinquency, and drug abuse were all duly noted. For the paperback edition of John Hersey's *Hiroshima*, artist Geoffrey Biggs created a cover that unsettled many readers. Biggs said he had merely thought back to that August morning in a large industrial city and imagined how universally terrifying the situation was, how it could strike fear in anyone's heart. "And I just drew two perfectly ordinary people—just like you or me—and had them portray alarm, anxiety, and yet wild hope for survival as they run from man-made disaster in a big city—a city like yours or mine."

With the technology and resources now available, "instant books" began to appear on the most compelling issues of the day. When FDR died in April of 1945, Pocket Books responded six days later with *Franklin Delano Roosevelt: A Memorial*, the first instant book. Following the bombing of Hiroshima later that year, Pocket Books published *The Atomic Age Opens* in a matter of weeks.

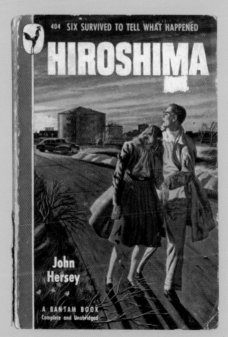

OPPOSITE: Pocket Books, New York, 1945. ABOVE: Bantam Books, New York, 1948. Artist: Geoffrey Biggs

POPULAR LIBRARY 25c "SHOCKING STORY"— New York TIMES

592

TEEN-AGE GANGS

Dale Kramer
and
Madeline Karr

Introduction by
Senator Estes Kefauver

"A startling and sickening story
of the unbelievable ferocity of
juvenile delinquency ..."
Houston CHRONICLE

Complete and
Unabridged

Teen-Age Hoodlums On The Loose

Jailbait

WILLIAM
BERNARD

Complete and Unabridged

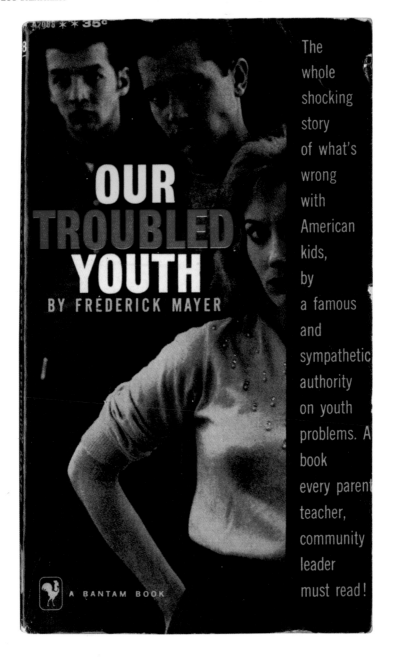

PREVIOUS SPREAD, FROM LEFT: Popular Library, New York, 1954, 1951. ABOVE: Bantam Books, New York, 1960. OPPOSITE: Vintage Books, New York, 1969

Eldridge Cleaver

author of SOUL ON ICE

Post-Prison Writings + Speeches

Edited and with an Introduction by Robert Scheer

A Vintage Ramparts Book V-567 $1.95

Featured Artist Biographies

JAMES AVATI

Avati was born in 1912 in Bloomfield, New Jersey, and studied architecture and archaeology at Princeton. He began his professional career designing window displays for Fifth Avenue department stores in New York City. In the 1930s, he moved on to magazine illustration. During World War II, he spent three and a half years in the Army. Following the war, he moved to Red Bank, New Jersey, and continued to illustrate for leading magazines including *Collier's, Ladies' Home Journal,* and *McCall's.* In 1948, he began illustrating covers for the New American Library. Replacing Robert Jonas's European-influenced graphic, poster-like style, Avati's brooding, realistic approach became wildly influential. His finest period was from 1949 through 1955, when he did many covers for Signet Books. In 1950, he began illustrating covers for Bantam as well. He was offered the job of art director at Signet but turned it down, preferring to focus on his own illustration. He worked from photographs that he took himself, employing both professional models and anyone else who was willing to pose.

PAUL BACON

Bacon was born in Ossining, New York, in 1922 and graduated from Arts High School in Newark, New Jersey. After serving in the Marine Corps during World War II, he went to work at the studio of the former promotional art director of *Fortune* magazine, Hal Zamboni, but soon moved to his own Manhattan studio above Carnegie Hall. Shortly afterward, Bacon was asked by a friend's father to illustrate a book on his African travels, *Chimp on My Shoulder.* Thus began a 50-year career designing book covers large and small. Bacon is credited with creating the "big book look": a large title and byline with a spot illustration or graphic. Bacon is also noted for his album covers for Riverside Records, and today still sings and plays the comb in a small jazz ensemble.

RUDOLPH BELARSKI

Born in 1900, Belarski first made his living as a slate picker in a coal-processing plant in Dupont, Pennsylvania. A picture he drew near the mine entrance led to his painting safety posters for the company. Self-taught, at age 21 he put himself through the Pratt Institute working as a waiter, sign painter, and private art teacher. He was invited back to teach commercial art at Pratt three years after graduation. During this time, he

began illustrating covers for pulp magazines, including *Mystery Book*, *The Phantom Detective*, *Popular Detective*, *Thrilling Detective*, *Western Roundup*, *Wings,* and many others that were published by Ned Pines. In 1942, Pines founded Popular Library, but it was not until 1948 that Belarski produced his first cover for Pines's paperback house. In 1957, he joined the staff of the Famous Artists School in Westport, Connecticut. He died in 1983.

SEYMOUR CHWAST
Chwast was born in 1931 in the Bronx, New York, and attended Lincoln High School in Brooklyn, where he studied with noted design teacher Leon Friend. He graduated with a bachelor of fine arts from Cooper Union in 1951. In 1954, he cofounded—along with Milton Glaser, Edward Sorel, and Reynold Ruffins—the internationally renowned Push Pin Studios. He has designed and illustrated many paperback covers over the course of his lengthy career, along with award-winning advertising and op-ed pieces, magazine covers, packaging, and typefaces.

TOM DUNN
Dunn was born in Gravesend Bay, New York, and raised in nearby Belford. He studied at Villanova University before joining the Marine Corps during World War II. In 1948, he completed his education at the Pratt Institute. Although he began his career in advertising and television, in 1951 he started producing paperback covers for Signet and later for Pocket Books, where he became their first full-time cover artist.

GEORGE T. ERICKSON
Born in Bridgeport, Connecticut, in 1924, Erickson studied at the Whitney School of Art in New Haven and the Pennsylvania Academy of Fine Arts in Philadelphia. His first paperback work was for Avon, where he produced approximately thirty cover illustrations between 1950 and 1951. Unhappy with their $150 fee, he soon moved on to Signet, who paid $400, and produced thirty-five covers between 1951 and 1954. At the same time, he illustrated for Bantam, Dell, Fawcett, Lion, Perma, Pocket, and Popular Library.

JACK GAUGHAN
Jack Gaughan was born in Springfield, Ohio, in 1930 and died in 1985. In addition to myriad science fiction and fantasy book covers, he illustrated covers for the science fiction magazine *Galaxy*. He worked primarily with

editor Donald A. Wollheim, first at Ace and later at DAW. Many of his Ace books also featured frontispieces and title pages displaying his distinctive calligraphy and maps.

MILTON GLASER

Glaser was born in New York City in 1929 and raised in the Bronx. He attended the High School of Music and Art in Manhattan, and following graduation from Cooper Union he studied via a Fulbright Scholarship at the Academy of Fine Arts in Bologna under Giorgio Morandi. Upon returning to the U.S. in 1954, he joined Seymour Chwast and others to found Push Pin Studios. Beginning in the 1950s, he produced scores of book covers, including many early on for Signet and Mentor art director Bill Gregory.

GERALD GREGG

Born in Lamar, Colorado, in 1907, Gregg attended high school in Racine, Wisconsin, where he won second prize in a poster contest in 1925 and was advised to attend art school. He graduated from the Layton School of Art in Milwaukee and began freelancing for the Western Printing & Lithographing Company in Racine, where he was eventually hired full-time. Western, in its partnership with Dell Books, assigned Gregg to illustrate Dell's covers beginning in 1943. Art director William Strohmer or assistant George Frederiksen would provide Gregg with color sketches that he would then flesh out, utilizing an airbrush and rendering the artwork in a decidedly European poster-like style combined with Surrealism. During this same period, Gregg also drew comic strips for Disney and Warner Bros. and all the back covers for the Little Golden Book series. He died in 1985.

GEORGE GROSS

Gross (1909–2003) was born and raised in Brooklyn. His father, David Gross, was a successful artist in the fashion industry; following in his footsteps, George also attended the Pratt Institute. His first pulp assignments were for *Mystery Novels Magazine* and *Double Action Western* from Winford Publications, and he soon became a top illustrator for Fiction House. He painted hundreds of freelance covers for *Action Stories, Air Stories, Baseball Stories, Complete Northwest, Detective Book Magazine, Fight Stories, Football Stories, Jungle Stories, North West Romances,* and *Wings* while working out of his father's studio at 15 West 38th Street in Manhattan, where he shared

space with his brother Arthur and sister Beatrice. He was disqualified from military service because of a serious impairment of vision in his right eye, which affected his depth perception and required corrective lenses. After the war, he began selling freelance illustrations to paperback publishers such as Ace, Bantam, Berkley, Cameo, Dell, Lion, and Star, and continued to work into the 1980s.

CLARK HULINGS

Hulings was born in 1922 in Florida and raised in New Jersey. He lived in New York, Louisiana, and throughout Europe before settling in Santa Fe, New Mexico. He studied under Sigismund Ivanowski, and at the Art Students League of New York with George Bridgman and Frank Reilly. Hulings also holds a degree in physics from Haverford College. He produced paperback covers for Avon, Cardinal Editions, Dell, Fawcett, Lion, Pocket, and Signet. These days, he is a well-known American realist painter.

ROBERT JONAS

Born in 1907 in New York City, Jonas attended the Fawcett Art School in Newark, New Jersey. While studying at New York University, he met painter Willem de Kooning and was deeply influenced by both Abstract Expressionism and European graphic design. In 1945, he produced his first paperback cover for Penguin, and went on to become Penguin's unofficial art director before being given his official title as type director. Penguin and Bantam art director Gobin Stair had this to say about Jonas: "Bob Jonas was a dominant and successful cover artist. He developed an idea and projected it powerfully without getting trapped by compromise. His designs worked year after year."

VICTOR KALIN

Born in Belleville, Kansas, in 1919, Kalin graduated with a bachelor of fine arts from the University of Kansas in 1941, where he taught drawing and painting for the next year. During World War II, he was a field correspondent for *Yank* magazine and produced maps and artwork for training manuals. His first illustrations following the war were for magazines such as *American Weekly, Collier's, Esquire*, and *Liberty*. These caught the eye of paperback art directors, and he was soon creating covers for Avon, Dell, Pocket, and Signet. At Dell, he painted covers for all of Mary Roberts Rinehart's books. Reflecting on his paperback career, Kalin

stated: "They were lurid and tasteless, and I considered the whole thing something of a lark, certainly not a serious business." He died in 1991.

ROBERT MAGUIRE
Maguire (1921–2006) began his education at Duke University, but left for service in World War II. Upon his return, he studied at the Art Students League of New York alongside Clark Hulings and Jimmy Bama and graduated in 1949. His career took off immediately with his first work for Trojan Publications, producing cover art for its line of small pocket pulps. His first paperback covers were for Pocket Books in 1953. He then moved to Signet, where he produced numerous covers between 1954 and 1958. He also did covers for Berkley, Dell, Hillman, Lion, and Monarch, eventually totaling over 600 in all.

LEO MANSO
Manso was born in 1914 in New York City and studied at the Educational Alliance and the New School for Social Research. During the war, he was art director for the World Publishing Company, which published both Tower and Forum books. He also worked for sundry hardcover publishing houses, and through Simon & Schuster became involved with Pocket Books. He produced so many covers for Pocket Books that his impact on its look was rivaled only by Jonas's at Penguin. He began teaching at Cooper Union in 1947 and went on to teach at Columbia and NYU.

BARYE PHILLIPS
Barye Phillips worked for Columbia Pictures' advertising department in the early 1940s and did training booklets and propaganda during World War II. He soon came to the attention of Sol Immerman, the art director of Pocket Books and a cover illustrator in his own right, who launched Phillips on his paperback career. His best-known work was for Gold Medal and other Fawcett imprints. During the 1960s, he served as president of the Society of Illustrators.

NORMAN SAUNDERS
Saunders was born in Minneapolis in 1907 and studied at the Grand Central School of Art with Howard Pyle's protégé, Harvey Dunn. Initially, he worked for Fawcett in Minneapolis producing covers, cartoons, graphic maps, charts, and technical diagrams in pen-and-ink and black-and-white gouache for publications such as *Modern Mechanix*, *True Confessions*,

and *Captain Billy's Whiz Bang*. He later moved on to a number of pulps, illustrating both covers and interiors, after relocating to New York City. His work was featured on the cover of *Eerie Mysteries*, *Ten Detective Aces*, *Wild West Weekly*, and *Saucy Movie Tales*. In 1938, he illustrated an early version of the paperback *Pocket Detective* from Street & Smith. He served in the Army during the war and, beginning in 1948, produced covers for a number of paperback houses, including Ace, Ballantine, Bantam, Handi, Lion, Popular Library, and Reader's Choice.

HARRY SCHAARE
Schaare was born in New York in 1922 and studied at NYU's School of Architecture and the Pratt Institute. Following World War II, he graduated from Pratt and began his own studio. He illustrated stories for the *Saturday Evening Post*, and his first paperback cover appeared in 1949 for Bantam. It was soon followed by work for Avon, Ballantine, Berkley, Fawcett, Lion, Popular Library, Pyramid, and Signet—over 450 paintings in all.

ROBERT STANLEY
Stanley began his career as a pulp magazine illustrator and went on to paint covers for Bantam, Lion, and Signet. He soon became a major Dell cover artist, and from 1950 through 1959 helped define the Dell look for that decade. His forte was adventure, Westerns, and mysteries. He often used himself, his wife, his father-in-law, and his daughter as models for his covers. The designers at Dell would give him a rough sketch, which he would work on and return as a color sketch. If this was approved, he would then photograph the scene and use that as a basis for his painting.

VERN TOSSEY
Tossey was born in 1920 in Detroit, Michigan. He studied at the Art Students League in New York under Frank. J. Reilly. Known for his Western and historical rugged realism, he married a rancher's daughter. Tossey worked in oils, poster paint and tempera. He died in 2002.

TROOP
Little is known about the artist who signed his (or her) work with this signature, and sometimes as "Troup" or "TroupB." Between 1942 and 1947, work by this artist appeared on several Pocket Books.

STANLEY ZUCKERBERG

Born in New York City in 1919 and raised in Long Beach, Long Island, Zuckerberg studied at both the Pratt Institute and the Art Students League. In 1940, he simultaneously began a career in the pulps and comic books (for *Classics Illustrated*); soon after that, he started producing work for the "slicks": *Cosmopolitan*, *McCall's*, *Good Housekeeping*, and the *Saturday Evening Post*. In 1949, he created his first paperback cover for Bantam, and went on to produce over 300 covers for Avon, Ballantine, Bantam, Dell, Fawcett, Pocket Books, Popular Library, and Signet. He would photograph his models himself and then paint in oil. He stopped doing paperback covers in 1965, switching to fine-art painting sold in galleries. He died in 1995.

Bibliography:

Baines, Phil, *Penguin by Design: A Cover Story, 1935–2005*, Penguin, 2006.

Drew, Ned, and Sternberger, Paul, *By Its Cover: Modern American Book Cover Design*, Princeton Architectural Press, 2005.

Hansen, Thomas, and Glaser, Milton, *Classic Book Jackets: The Design Legacy of George Salter*, Princeton Architectural Press, 2004.

Haining, Peter, *The Art of Mystery & Detective Stories*, Treasure Press, 1977.

Heller, Steven, "Mapbacks: High End of a Low Art," *Print*, May/June XLVIII:III 1994.

Lesser, Robert, *Pulp Art: Original Cover Paintings for the Great American Pulp Magazines*, Castle Books, 1997.

Lyles, William H., *Putting Dell on the Map: A History of Dell Paperbacks*, Greenwood Press, 1983.

Lupoff, Richard A., *The Great American Paperback*, Collectors Press, 2001.

Lasky, Julie, "Design for the Masses," *AIGA Journal*, Volume 11, 1993.

Meggs, Philip B., and Purvis, Alston W., *Meggs' History of Graphic Design*, Fourth Edition, Wiley, 2005.

Schreuders, Piet, *Paperbacks, U.S.A.: A Graphic History, 1939–1959*, Blue Dolphin Publishing, 1981.

Server, Lee, *Over My Dead Body: The Sensational Age of the American Paperback, 1945-1955*, Chronicle Books, 1994.

Acknowledgments

First and foremost I want to thank my former coauthor Julie Lasky for her enthusiasm and support both for the subject and the project and for coming up with the coolest name ever for a book. I also am indebted to Steven Heller for his insight and willingness to share his talent and expertise. At Rizzoli I can't thank Charles Miers enough for agreeing to publish and support this book, my editor Jane Newman for her help and guidance beyond the pale, and Ellen Nidy who aided in the process along early on. Likewise head of production Maria Pia Gramaglia and Claire Gierczak and Kayleigh Jankowski. Also thank you to Beth Honeyman for her permissions expertise, and Bruce Black of Bookscans for his support. I am deeply indebted to my friends and colleagues who allowed me to show their wonder art: Paul Bacon, Seymour Chwast and Milton Glaser. And to my former mass-market bullpen mates John Gall and Morris Taub. A special thanks to my former art director at New American Library George Cornell, who took a chance on me and got me into this mess in the first place. And lastly, to Kati and Janna, who somewhere along the way realized it's better to let me get these things out of my system.

Index

Page numbers in italics refer to illustrations.

Signet Books, New York, 1955

author of "A STRETCH ON THE RIVER"
and co-author of "THE PAJAMA GAME"

A SIGNET BOOK
Complete and Unabridged

HAROLD ROBBIN

author of THE CARPETBAGGER
THE DREAM MERCHANT

NEVER LOVI
A STRANGEI

CARDINAL EDITION
GC • 602 60¢

Other Novel by Harold Robbins:
GC • 764 The Dream Merchants

If your bookseller does not have these titles, you may order th
by sending retail price, plus 5¢ for postage and handling
MAIL SERVICE DEPT., Pocket Books, Inc., 1 West 39th
N. Y. 18. Enclose check or money order — do not send ca